So You Want To Be A Rockstar Photographer

By GARY FONG

Published By LSH Publishing Co.

LSH Publishing Co.

Library Of Congress Cataloging-in-Publication Data
is available for this title
978-0-9859178-0-7

Edited by Andy Wolfendon
Cover Art by Ranilo Cabo

0922121000

Table of Contents

The Myth Of The Rockstar Photographer

The myth of the portrait/wedding photographer "Rockstar" is comparable to the myth of "The Loch Ness Monster". Both are media sensations, both have a core of fervent believers who are happy being separatist from the public at large. With the social media network of Twitter, Facebook Fan Pages, and Blog templates, the myth of the portrait/wedding photographer's life as "Rockstar" glamorous has spread like a virus through the photography industry, and some are getting hurt by it.

The Rockstar Photographer myth promises exotic destinations, private planes, traveling by limo, and wearing really cool clothes all the time.

Because of the advances in the accuracy of "Program Mode" in low-cost DSLR Cameras, the ability to capture better images has brought a whole new demographic of enthusiasts who are inspired to go pro by workshop presenters promising the life of a millionaire.

Scan YouTube, and eventually you'll find a video promoting a workshop presented by two women photographers. The video shows them arriving at a private airport hangar, as a 2003 Land Rover Discovery pulls up to a Cirrus Private Plane, where they're filmed doing the slow-motion runway stride (pulling Louis Vuitton Luggage) to meet their pilot and board their plane. As we watch it take off, they offer a workshop that will "kick your ass" and help your studio succeed, because, "you need to make $$$".

Since they're from Southern California, about an hour from my hometown, I asked my photographer friends

who live in the same city, and none of them had ever heard of them. The message is baffling. Do these two girls have so much success that they fly around in private planes? Though it's never explained, it gives the glimmer of a millionaire lifestyle, and this is huge to a fickle electronic audience.

It's so ironic that in a time where even making a living in photography is becoming more difficult daily, (with all of the low-cost novice photographers offering to shoot at low prices to build their portfolios) success seminars have grown at about the same pace as the industry has gone down!

The phenomenon is not a harmless one. It is diluting the skill, trust, and professionalism of professional photographers. It will soon come to a point where the public at large will be skeptical of *all* professional photographers as "posers". There are couples out there that now have no decent photos of their most important life events because, in blind faith, they hired unqualified photographers who appeared masqueraded as experts.

These shooters can get away with it easily, because they attend "shooting workshops" where real pro photographers hire models, stylists, and makeup artists, set up poses, and let workshop participants shoot with their own cameras. The resulting images wind up on slick websites that look highly professional, but are built from templates. A naive public then hires the inexperienced photographers, and the result is not only disappointment for the client, but lawsuits, ruined lives, loss of homes and retirement plans, and sometimes even prison sentences for the photographer!

I personally know half a dozen newly minted "professional" photographers (who in the last 12 months) shot one wedding and quit forever under the pressure and the intense fear of prosecution or civil lawsuits. I am not kidding! That's because we've been building a new culture in the photography business that puts style before skill, marketing before mastery. And people are getting hurt on both sides of the camera.

Social media can instantly make a superstar of Taylor Swift, or Justin Bieber. Twitter can instantly form "flash mobs" in the Grand Central Station, and Facebook helped topple regimes in Libya, Tunisia and Egypt. It can also instantly make superstars of photography, who are spectacularly adept at Twitter and Facebook, yet are comparably weak in business and photography skills.

The top professional photographers are too busy working to broadcast clever Tweets every hour to stay on top of the heap in the popularity contest. Ask any neophyte budding professional photographer the name of the wedding photographer who shot Jen and Brad's wedding, and few will know. But they know the hottest stars of the moment, stars who dress up in trendy clothes and appear in publicity photos that look like they belong on the cover of an Abercrombie catalog. Social Media-created celebrities can create an audience so quickly, that a brand new professional photographer (with no track record of success) can charge $1,500 per person for a twenty-person "Success" workshop (yes, that's, ahem, $30,000) from a trusting crowd.

The irony is that there are more "Rockstar" style success workshops than ever, in a time where it's harder than ever to make a decent living in photography. These

3

"Rockstars" don't have successful photography business-es, but offer to share secrets they don't actually possess, promising secrets of success they haven't actually at-tained.

That's why I'm writing this book. I want to uncover the Rockstar myth. I want to examine the sultry temptation of instant Facebook fame, and how it can understandably lead these instant celebrities to want to cash in. This isn't just limited to wedding and portrait photography. This type of thing is happening in all "Rockstar" industries, from faux-Screenwriters giving workshops on how to get their manuscripts made into feature movies, to health and fitness gurus claiming diet miracles. If you can scream loud enough in the blogosphere, you can enjoy a brief moment in time where the fickle crowd has you in their spotlight, only to move on minutes later.

But more than a social commentary on how the speed of Tweeting can dilute an entire industry, I also want to share some hard-earned, practical wisdom that will help you achieve actual success. The real stuff. I can't promise to raise you to Rockstar status, but if you follow the advice I'm going to offer in this book, I think I can get you a lot closer to success than those overpriced recyclers of "The Secret" that are currently crowding the seminar dockets.

In the first part of the book, I'm going to share the be-hind the scenes stories of some of the industry "Rock-stars," let you see how they can also become caught up in the same frenzy as their followers, wind up over their heads in popularity, only to find the crowd has suddenly moved on as you make plans for an even bigger tour.

I also wish to help you to become a more discerning,

question-asking consumer of photography books, courses, blogs, and seminars. (You can still choose to spend your hard-earned money on success workshops, but you should at least follow mentors who can really help your career, not just fill you with an instant inspirational high.)

In the second part of the book I'll offer you some extremely valuable, real advice about how to train, prepare, market, and legally protect yourself in your new career as a photography professional. I'll give you reality-tested strategies and tips that took me years and years to learn, and that actually work, out there in the real world. It's going to take real work, not posing like a celebrity.

Professional photography is a very serious profession, and screwing up because of inexperience can totally ruin your life.

Disaster Stories

Are you ready to turn into a full-time professional as a photographer? Are you sure?

The following accounts are composites of real-life stories that happened to real-life people.

If you think that becoming an "instant" professional photographer is a good idea or an easy task, I hope these stories scare the hell out of you. Not because I want to be mean (or to be a so-called "grumpy"), but because I want to protect you. And no one else out there seems interested in doing that these days.

The Destination Location Shoot

She was thrilled to land her first big location assignment. An investment banker from London had hired her via her impressive-looking website. She was to be flown to Central Park in New York City to photograph his surprise proposal to his girlfriend. This was a once-in-a-lifetime moment. Fittingly, the client offered the photographer a sizeable fee, airfare, and other travel expenses.

She had been shooting for three years on paid assignments, mostly for friends (at a deep discount), and friends of friends. She didn't have in-depth knowledge of camera operation, but why learn more than she needed to? She knew how to use Program mode, which had served her well so far. If Program mode guessed wrong, she could always fix it in Lightroom post-production editing.

This assignment was different, of course. This was a

world-class job, usually reserved for the Rockstar pros. Recognizing the huge leap her career was about to make (this gig would look amazing on her blog), she went to a famous photographer's shooting workshop to gain the training necessary to take her skills to the next level.

At the workshop, the famous pro photographer kept announcing his f-stops and shutter speeds. He preferred shooting in Manual mode (for reasons that any professional photographer can appreciate) and drove this point home over and over again.

With so much going on in her mind, the one thing the would-be Rockstar remembered from the workshop was the advice that had been repeated so often: "shoot in Manual mode."

The day of destiny arrived, and the plane landed in New York City. Welcome to the Big Time. Rockstardom awaited.

Although she had previously shot only in Program mode, she followed the advice of the Master Photographer and moved the big dial on top of her camera two clicks to the left, from "P" to "M." And proceeded to change nothing else.

In case this needs explaining: when you set your camera to "M," your shutter speed and f/stop will be left wherever you last set it. And that's exactly what happened in this case. Which was a recipe for disaster.

Outdoors in Central Park in the afternoon, in open shade, the exposure should be around 1/500 sec at f2.8 — 1/1000sec at f2.0, 1/2000sec at f1.4, etc., at ISO100. Most

professional photographers understand that outdoors on a sunny day, there's what is called a "sunny 16" rule, which means that at ISO100, at 1/125th of a second, your lens should be set at f16.

Working from there, and allowing one stop for tree cover, you ratchet the shutter speed inversely to the aperture opening in order to quickly calculate where the lens should be set.

But our heroine was a bit sketchy on such matters. She did, however, possess a dandy Diane von Furstenberg silk V-neck top, which she hoped was serving her well.

The big moment came as the investment banker and his soon-to-be fiancée appeared in the clearing in the park. The photographer was firing images rapidly as the couple approached. The banker knelt on his knee as the bride-to-be froze with glee and threw her hands up over her mouth. He opened the box, put the ring on her finger, and they cried, kissed, and held each other for at least 75 exposures.

The telephoto lens was a great choice. The photographer had found the perfect hiding spot, too, and was capturing the images like a paparazzo. Swelling with pride and anticipation, she checked her LCD screen and hit the "Play" button.

White. Completely blown out. She hit the back button. White.

Frantically, she clicked the back button, again and again. White. All white. All of the images were completely blank canvases. Heart pounding, she pressed the

INFO button and a histogram showed up. This, of course, meant nothing to her.

She hit the INFO button again, and the shutter speed showed 1/60 second at f4. Five stops too overexposed for a sunny day in open shade.

A glimmer of hope struck the photographer's mind. The images were shot in RAW mode, and she thought maybe she could fix the exposure problems in post-production. But upon sitting down at her computer, Lightroom couldn't do a thing. There was no image at all.

She sent the pictures to experts at a major digital photo lab. They told her the same thing. There were no images on the camera whatsoever; they were entirely blown out. And as with any once-in-a-lifetime event, the proposal she had been hired to capture could not be restaged.

I don't know what happened from this point forward. I have no idea how you explain a situation like this to your client. Did the photographer have to reimburse the airfare and other travel expenses? Most likely. Did the client seek damages? Possibly.

Probably the worst thing of all for this wannabe Rock-star was that she had no Big Time event to dish about on her blog.

Fame and fortune would have to wait.

First-Wedding Nightmare

The church ceremony had just ended. The photographer glanced at his little LCD and saw what looked like an image from a television with no antenna. Just scrambled lines. Static noise. He took another shot, same thing.

It appeared that the camera was broken. Luckily, he'd packed a backup camera, an EOS Digital Rebel he'd borrowed from his friend. He pulled out a fresh CF card to format it for use in the backup camera.

The bride interrupted his thought process with a photo request, so, in a rush, he threw a CF card into the backup camera. Problem was, he had two cards in his hand. One contained all of the images from the wedding so far, and the other one was to be formatted. He formatted the wrong card.

The images were gone, but not deleted forever. Inexperienced in dealing with CF cards, the photographer didn't realize that if he put that card away, right now, and avoided further shooting on it, the images could be recovered in a snap. Instead, bowing to pressure from the wedding party who were looking annoyed at him because he was taking so long to pose shots, he just continued shooting on the newly formatted card.

This poor shooter made two huge newbie mistakes. First, he juggled two cards in the same hand, which you should never, ever do. Second, he shot over the formatted card. When you shoot on an erased card, that's when you create a problem. This obliterates the old images (which would have been recoverable otherwise), because the new images overwrite them.

All of this was compounded by his inexperience with posing people. Nervous about taking too long with shots, he rushed a decision that should have been made more thoughtfully.

As a result, all of the images of the wedding day, up to and including the actual wedding ceremony, were gone forever. But this shooter's woes didn't stop there.

Almost all of the images he managed to capture for the rest of the day had problems, too. The shots of the groom's wedding ring on a blanket, along with the few portraits he got of the groom sitting on a hotel lobby arm-chair (awkwardly posed like the Lincoln Memorial), were unusable because they were shot at low resolution. (He didn't realize till later that the backup camera had been set up for Internet-sized files.)

The photos of the bride's shoes, back to back in book-mark style, had to be shot on a small end table in a hotel room lobby, with the exit sign visible in the background, because he was unfamiliar with the venue and couldn't find any better locations. These images were also grainy, blurry, and underexposed because they were shot handheld at high ISO.

The photo of the bride's engagement ring in the delicate stamen of a Gerber daisy was a mess because he had smashed the ring into the flower in pure frustration.

Shots of the bride and groom at the reception venue were either starkly lit with direct flash and black back-grounds (photographer had the camera set at ISO100 by mistake) or grainy and blurry because of long, handheld

exposures, which became necessary when his flash unit ran out of batteries.

And those were the images he had. What he didn't have, of course, were images of the ceremony or the dressing room beforehand. He had no photos of family groups or wedding party members either before or after the ceremony. Not knowing the typical schedule of a wedding day, he didn't realize that once the wedding party gets to the cocktail hour, and the drinks start flowing and the ties get loosened, it's impossible to corral anyone for group photos.

The result of this nightmare day was a lawsuit from the couple. They filed for unspecified damages (to be determined by a judge) owing to fraud and breach of contract. It was not a small claims suit, either; they were seeking more than the $5,000 limit. In their three-page complaint, they also sought an order from the court that the photographer pay for tuxedo rentals, flowers, dress cleaning, and travel for the out-of-town wedding party members to do a reshoot.

The couple won big. The judge gave the plaintiffs a $20,000 award and ordered the photographer to re-shoot everything at his expense, including travel costs, flowers, and tux rentals. The grand prize was that he got to do this in front of an irate couple that had just sued his pants off and won.

Total cost to photographer, $37,000. Wait— correction—$36,500 because, after all, he did collect $500 to shoot the wedding.

One year later, after losing his house and his spouse's

401K plan, he took down his website and removed the title, CEO of Photography Studio, from his "work" profile on Facebook.

A wedding is a fast-moving, high-pressure scenario, with no Pause or Rewind buttons. Inexperience causes photographers to set their cameras on the wrong settings, miss important shot sequences, and to be flat-footed when it's time to jump. New photographers sometimes shoot the whole event on file sizes that are unsuitable for printing. These errors aren't discovered until after the event, when there's no way of going back. Other times there are file management issues, where the photographer thinks he has backed everything up to a hard drive, only to find out, after reformatting the CF card, that he backed up only the "alias" files, which contain no information other than where the original file is located.

But the real panic comes when something goes wrong during an event. You're standing there with everybody staring at you while you stare at your LCD screen alert that says, "File Format Error." What does this mean? It won't let you shoot anymore, and it won't let you review what you've already shot. Are the shots gone?

Lately, huge communities have been forming online encouraging pretty much anybody with a D-SLR to "jump in," "take the big leap," and become a full-time professional photographer. One widely criticized campaign even urges the novice photographer to "spray and pray," which means to aim your camera at a subject, put the camera on Program mode with the motor drive at the highest speed possible, and fire at the target like an Uzi.

But maybe you're skeptical of this type of fanatical be-

havior. You want more knowledge from experts in the field.

So where do you turn to learn more? Maybe you should take a seminar?

You've heard of industry Rockstars who are hugely successful at photography. What do they know that you don't know? Who are these "Rockstars" of photography, and how did they get to be so big?

Rockstar Profiles:
"Tom" -Rockstar #1

Tom was always reading or blogging about the newest, trendiest success books, as well as the Bible. Having been a faculty member at a Bible college, he had honed his ability to draw a crowd and keep them in rapt attention. He had a smooth oration style and an affable, telegenic persona. He's a dedicated family man, and a warm, inviting person to socialize with.

He started to emerge on the radar by uploading whimsical, yet informative, video tips on photography. These began to garner a following. At around this time, I began advising him. I asked him why he was putting all of this effort in broadcasting videos without monetizing them at least a little. He explained his strategy of building a following first, then monetizing when the time was right, which made a lot of sense.

Though he had a full-time "day job," his mind seemed to be constantly working on strategies that could make him a leader in the photo industry. His drive was powerful. He surrounded himself with successful people. He digested every bit of success advice he could get his hands on and began Tweeting cutting-edge business ideas from proven thought-leaders. This would position him as an authority on business.

One day he ended his day job and jumped full-time into photography. His photography business showed encouraging signs of growth. I encouraged him to throw himself hard into his business, and he started doing great. So great that before too long, it was no secret that he had one of those cool stainless steel, bullet-shaped Airstream

trailers (just like Matthew McConaughey), and a trendy Vespa Scooter, great visibility stuff when you're campaigning for more "Likes" on your Facebook Fan Page. Such expensive status symbols are a fantastic attention-getter in the extremely fickle social network audience.

With the popularity, he decided to write a book. He got a book deal with a major publisher, and received a hefty advance and a *two* book deal.

Tom's book was aimed at a target audience of neophyte professional photographers and amateurs considering going full-time. It was perfect timing.

His first book did really well. It was a direct hit to a message this new crowd wanted to hear; that becoming very successful as a professional photographer was not as daunting as everybody thought. He was autographing copies and giving workshops. He also had an emerging photography business that he needed to maintain in order to have credibility as a successful photographer/author. But because speaking and giving workshops appeared to be more profitable, his energies were directed there. Though he had little experience in the actual field of photography, he was able to charge a high fee per student and travel the world giving seminars and speeches because of the following he collected.

I had never seen somebody Tweet so often.

He was precise in executing tweets ahead of the upcoming cities on his "tour," causing a leapfrog effect across the U.S. and internationally. It became very lucrative very suddenly.

He was named one of the top 30 photographers in the world according to a well-regarded Photography magazine, on the same list as Annie Leibovitz. The survey was a result of internet polling, which gave a clear shot to the top for people who knew how to get followers to not only vote for them on the survey, but to Retweet it virally. The list was widely ridiculed, and most of the other photographers on the list soon ceased mentioning it in their PR.

He was a platform speaker at WPPI (Wedding and Portrait Photographers, International), putting him in front of an audience of over a thousand people. WPPI drew 12,000 people, a majority of them female. As he stood at the podium, the sea of faces looked eager to hear his message about how to take the shortcut to Airstream-hauling, Vespa-riding success. Though his actual success as a photographer was not extraordinary, his lectures on strategies for speedy success whipped these folks into a frenzy.

The talk was hugely inspirational, filled with esoteric ideas like assessing who you are in order to be the best photographer you can be. Everyone was glued to their seats for the entire presentation and swarmed the stage afterwards, wanting to sign up for more educational opportunities and to get their books autographed. Major sponsors were expressing interest.

Tom next created a "society" in which specially deputized "trainers" could carry his concepts to people the master himself couldn't reach. In launching the group, he also created a "Founder's Group." This strategy has been shown to work tremendously in the televangelism world. Giving followers a name (e.g. "The PTL Club") makes loyalty stronger and raises the pitch of the fervor. For a price equal to about three monthly car pay-

ments, the first 500 people who joined the Founders Group could have their names published on the group's website. If the Founder's Group filled to capacity (and by the looks of the crowd, it would), that would mean a cool $750,000 for him. Adding up the society membership dues, the $750 monthly fees for "mentoring" consultations by phone, and the workshop fees for the always-filled workshops, it looked as if a potential multi-million dollar income could be earned from success-mentoring in professional photography.

Not bad for a photographer with a not-yet established business, which had started his shooting career only a few years prior.

He grew a beard, declaring to his public that he wasn't going to shave until the sequel to his book was finished. He was hounded for his autograph. His success leadership expanded into fitness tweets. Remarks like "Commit to breaking a sweat 300 days this year" would trigger a cascade of retweets from his followers, with "amens" thrown in. He began to morph into a sort of lifestyle coach, showing the faithful how winners not only make huge amounts of money (with photography), but also have tight, firm abs that everyone envies. Diet tips, exercise tips, and words of wisdom were absorbed and retweeted by the crowd, and the crowd was growing.

If you have to tweet something every day to keep yourself in the glare of the spotlight, eventually you'll run out of things to say. It's important to tweet in social media marketing to stay in the narrow beamed spotlight of celebrity.

In his second year on the road, he launched his second

book tour and added even more dates and cities. He was constantly on a plane. He was a jet-set Rockstar, lecturing to audiences, racking up frequent flier miles, and signing books. He had photos on his blog and websites showing his students carrying him aloft like a prophet.

He had to follow up his popular first-year message with a sequel of fresh material. After all, you can't give the same presentation two years in a row. So Year Two would be have to be even more inspirational. His content became more broad-reaching than mere photography business management skills. The message became less technique-driven, more conceptual. Motivational. Inspirational.

It was lost on the crowd, and the crowd began to shrink.

Right around the peak of his celebrity, he planned a very ambitious educational event with a number of well-known photographers over a multi-day program. The ticket price would have been an okay value, considering the number of speakers he had coming. But he made a costly error. A few days after the tickets went on sale, he announced that the whole event was going to be webcast for free. People who had made travel plans to come to the event were understandably furious, and some demanded refunds. Had they been informed that the event would be a free online streaming event, they could have avoided the expense of attending in person.

And as the fickle crowd often does, it turned on him in an instant. The internet anger increased in volume, and the result was smaller ticket sales. He shared with one of his "mentors" that it was a six figure loss.

I honestly think that the frenzy of attention helped create an atmosphere where things got really out of hand for him, and things spiraled out of control. The instant celebrity that you can amass on the social network is powerfully seductive. I can see how your ambition could grow as the applause gets louder, justifying bigger and bigger events.

But if you make the teeniest mistake, or run out of material, that fickle crowd is going to move to the next "big" thing as fast as a flash mob can assemble in Times Square.

His fifteen minutes were coming to an end as the crowd lost interest. He was struck by the "Jonas Brothers out - Justin Beiber in" fate. The photographic seminar/workshop circuit had quickly moved on to the next big star.

As of 2012, I've heard that he did a well-received program at WPPI. I am on his Twitter feed. Tom's newer programs are based on what he does best, interview people. He's a solid interviewer, and he is rebuilding his brand basically as a broadcaster/interviewer, rewiring his position as a personal coach for success to a student of the success techniques of others.

"Brad" – Rockstar#2"

Brad left college early because he was exploding with ambition to be an entrepreneur. And it was a good move, because during the time that he would have been stuck in school, he built a huge following and a strong business. He lived in a Rockstar home with a panoramic view of the ocean. Flocks of social network fans would retweet his sage advice with doe eyes. He established an audience of ambitious new photographers seeking community, leadership and training. Brad was a community expert. He knew how to form communities by creating online discussion forums, and filling content to his Facebook page with constantly attention-getting messages.

He had shot only a few weddings, but because of his fantastic speaking skills, he quickly became a photography celebrity. I encouraged him to consider monetizing his popularity if he had a good product to sell.

He and I partnered to create an OEM version of his software that displayed virtual completed weddings online in a slide show format. I had gone on a twelve-city national lecture tour about album pre-design, and his software was a solid success. It sold like crazy.

One day, when a group of us were vacationing in Cancun for my birthday, he saw firsthand how I had sold over $180,000 of a new product in one day. At that moment, I honestly think he became a changed man.

He asked for my advice in monetizing his product and his celebrity status with a tour of his own. It was a great idea!

As he made plans for his first national lecture tour, he reasoned that it would be more cost-efficient to rent a million-dollar Rockstar tour bus (at $55,000 a month) than it would to purchase air and travel for his entourage. Not only was that a business move, it was a publicity sensation. The million-dollar tour bus was a huge draw for what would become the "rockstar" myth.

Because he was renting the bus for an entire month, he was allowed to apply graphics to the outside. Having the bus "wrapped" would cost a hefty $17,000. But he was sure sponsors would pay to have banner space on the truck, so he went ahead and had the graphic designed. It kicked ass. It featured a large portrait of his face with his "opening act" speaker behind him at about half his size. Sponsors' names and logos would take up some of the rest of the space. (Later on, the decision to have his face plastered on the side of a million-dollar rock-god tour bus would result in widespread ridicule, but at the moment it seemed like a great idea. After all, a lot of his marketing was centered on his face. He was movie star handsome. His official logo, in fact, was an etched profile of his portrait.)

On tour stops he'd leave the bus parked in front of the hotel, and fans would take turns taking their photos beside his huge face, mugging it up like tourists on Hollywood Boulevard's Walk of Fame.

He hired a personal assistant to accompany him on the tour bus, as well as a full-time videographer to document his life on the road. Because he had a full-time videographer, he had to have his own makeup artist so he would look good for the videos. Not bad for a wedding photographer with just a few years of experience!

There were two keys to his being named one of the "30 most influential photographers of the century" by a prestigious magazine (the same list that included Brad). One was internet popularity. The voting poll was done on the internet, and skilled social networkers quickly pounced on the ability to attach a link to their tweets and ask their followers to "like" them. Thus, it came to be that he (as well as "Tom", Rockstar#1) would wind up on the same list as Annie Leibowitz.

He also found a lot of success attaching his religion to his marketing and messages, and organized prayer groups at conventions. The other growth factor was his message of affluence. His video broadcasts spotlighted the ocean view from his Rockstar crash pad and showed his friends hanging out by the pool and Jacuzzi.

But make the teeniest mistake and the crowd will stomp on you like an army boot can stomp on a grape.

As the tour was winding up, an independent workshop promoter arranged one additional stop. The deal was this: if there were at least 100 people in the audience, there would be no speaking fee paid to Brad. (That's because he would presumably make his income from product sales.) But if there were fewer than 100, Brad would collect his normal speaking fee, at a day rate in the thousands.

On the day of the program, some had driven for hours for the appearance. The headcount came up quite a bit short and, as per the agreement, Brad demanded his fee. At this point, he had to be exhausted. He had done so many cities on this tour, and this presentation had been added to his schedule to follow the end of his tour-bus

tour.

The promoters seemed hesitant to start the program, although the crowd was already seated. Brad began to suspect that the promoters weren't going to pay him, or were going to try to pay him less than agreed upon. So he made the decision to not do the program until he got paid.

Time passed. The crowd was informed that their speaker was upstairs in his room, but refusing to come out. Many of these fans had driven for hours to see him in person, and they were upset that he was a possible no-show. He sat in his room, broadcasting internet messages about how he felt hoodwinked. The room emptied out as the audience grew tired of sitting around in front of an empty stage. Some resorted to sliding notes under his door pleading him to come down and make an appearance. He refused; apparently this had become a war of wills. His fans were collateral damage. Yeah, it would suck for them if he was a no-show, but whose fault was that? The promoters, not his.

Upon his return home, black clouds began forming on the horizon and the wind was at his face. The vitriol from the angry seminar-goers had gone viral. He was accused of being a prima donna—too good to come out and greet his public. Emails to him went unanswered. Why? Perhaps because he had learned from the popular book, "The 4-Hour Work Week" that being unavailable adds to the mystique of your professional aura. This is a "Rockstar" idea, as I don't think if I emailed Bruce Springsteen, he would write me back right away.

An entire website was created to spotlight his purport-

ed "lies", and this website became the epicenter of an angry hate storm. A graphic designer released an image of the Rockstar tour bus nose-down in a lake, about to sink.

Soon after this event, the crowd again moved to another hottest star of the moment. Which actually was a good thing, because not only was the next hot thing a close friend, but she was the opening speaker on his tour. She would take over the baton of doing the important "evangelizing" of his software products, so seeing the crowd move on wasn't so devastating.

"Khloe" (Rockstar#3) was bright, funny, attractive, sincere, and a former UCLA Law student. She was a huge hit on the tour, appealing to a new demographic that was growing rapidly in the photo world—young females. Armed with D-SLRs that delivered decent Program Mode images, these shutter gals were able to bypass the need to understand photography basics, such as ISO and f-stops.

This demographic was growing virally, and a handful of accomplished and stylish photographers began to surface with blogs and images that looked like they came from the Anthropologie catalog. An accessory line of gadget bags with interchangeable fabric covers in stylish colors and patterns became a fad among the "momtographers" and became part of their uniform.

This telegenic young lady would soon be tremendously famous. She would soon unseat an accomplished and talented photographer, Jessica Claire, as the hottest photographer of the moment.

Jessica Claire was the first ginormous female star. At the major photo conventions, she was always swarmed

with admirers. And she deserved it. She had an amazing website and blog. Her work was top-notch. She was one of the most gifted photographers around. After ten years as a pro photographer, she had finally become an "overnight success." Her images were rich with saturation and she used retouching techniques that were unique at the time. Her branding was colorful and vibrant. She was an excellent blogger and very, very stylish. She struck a chord with a lot of women who found her "relatable."

She introduced a great product – a specialized camera bag for women. It had changeable covers with many stylish fabric patterns. Her bag became part of the uniform for the modern female professional photographer.

Every blog post she wrote was responded to with hundreds of comments, and there was constant demand for her words of wisdom. Eventually it got exhausting for her, and she chose to re-dedicate herself to her booming photography practice. She took a year off from blogging, and her social media channel went silent. Well, nature hates a vacuum. I tell you this internet crowd is fickle!

The moment she stepped off the stage, she left it wide open for someone else to take the spotlight. Tom was in a great position to promote Khloe as the new spokesperson for his company. Khloe was already building a tremendous following with her well-written and touching blog entries. She had okay photography skills, too, but, most of all, she had the "intangible" qualities needed to dethrone Jessica.

When Jessica resurfaced from her hiatus, she found that her celebrity and fame had evaporated. To her, this was a blessing because her photography business was flourish-

ing, and she was now free from the burden of thinking up something cute and clever to tweet about every few hours.

For Khloe it was a blessing, too.

"Khloe" - Rockstar #3

On the bus tour, Khloe had a great "Oprah"-like quality—an immediate connectivity with women that was palpable. She truly had a Rockstar persona.

Hearing her speak was like watching an episode of "The View" but with all four ladies rolled into one. In fact, it was right around this time that the term "Rockstar" was spreading throughout the industry, and the phrase, Rockstar Wedding Photographer (RWP), was coined.

I will forever be baffled by that phrase. Do these photographers arrive in limos? Do they trash hotel rooms? Do they snort coke? Do they hire hookers? Do they die by drowning in their own vomit?

Something inherently screwy is going on when the person behind the camera becomes more important than the person in front of it.

RWP became a common acronym and was used to promote workshops and tours everywhere. Often, these workshops were offered by complete newcomers who literally dressed like Rockstars in their promotional videos. Their tweets were more about the high-end status of their bookings, rather than the client's names:

> *Tweeter*: "I am so blessed to shoot this wonderful wedding at the Four Seasons Hotel."
> *Retweeter*: "You go girl! You are a true Rockstar!"

Within a year, Khloe would become the biggest Rockstar of them all. She would pack halls at the largest conventions. She would walk through trade shows with a

bodyguard! Her tour dates were nearly sold out, and she traveled on the same Rockstar tour bus as her predecessor, Brad. Instead of SmartCar-sized photos of her head on the side of the bus, though, it featured biblical quotes about serving others.

When participants entered the registration area for her workshops, they would often wait up to two hours to approach the "Step and Repeat" media wall (a white wall with logos plastered on it, typically seen at Hollywood premieres), just to have a photo taken with her.

Khloe's message was heavy on inspiration and diffuse on content. Her inspirational affirmations enraptured crowds. "You can DO this!" "It's time to BELIEVE in yourself." Though she was a good photographer, she didn't have the talent and experience of her mentor superstar. But she did have the magic ingredients for instant fame in a Kim Kardashian-worshipping world.

Her blog posts were witty, cute, and had a very down-to-earth aura. Her audiences were 90% female, and the lines outside the door looked like a queue for a screening of the latest sequel of Sex and the City. Girls wore sequined tops and flaunted their Jimmy Choo heels. After each tour stop, seminar participants tweeted comments such as, "She rocked it," and "I loved her hair"; "Thanks for reminding me that I truly CAN be somebody!"; "Looks like I have to rebrand myself"; and "Girl, where did you get that black sequined top?"

Regarding photography, she once told a crowd, "You don't have to be good, you just have to be popular." And, sadly, she's absolutely correct, in a way.

Her personal revolution created a horde of followers who did meet-ups and formed secret Facebook groups. They were wild with enthusiasm and fired up with the belief that they too could live a "fab" lifestyle and be the "totally hawt" creative artists they dreamed of ing. "Now is the time—you can be somebody!"

Her following grew to such a size that she published her own magazine, at $29 per issue. It was a huge hit. It supposedly documented her inner struggle, her "journey." The promotional video looked like a behind-the-scenes tour of Kelly Ripa's TV show. There was footage of a glamorous photo shoot and Khloe reviewing proofs on a light-board with a sassy little shake of the hips. Tellingly, the whole video featured a fast-paced photo shoot, but you do not see Khloe holding a camera. She was the model.

Her fame spawned a tremendous tide of emulators.

Affectionately known as "fan-bots," her followers created look-alike websites, with look-alike poses, and used Photoshop processing techniques that were obvious imitations. Khloe, in turn, emulated Jessica Claire (the one who had taken a year off). So now the Internet was flooded with a third generation of imitators. These imitators even tried to copy the style of prose on the Rockstar's blog. Evidently, they took her inspirational speeches seriously and truly believed they could "be somebody." Unfortunately, the somebody they believed they could be was her.

The CEO of WPPI told me that he began getting an avalanche of pitches from people who wanted to speak at the next convention, claiming to be the "next big thing." A crowd of hungry understudies was massing in the wings,

waiting for the star to dim as quickly as Jessica's.

"Kathie Lee" - Rockstar #4

After every trailblazer come the first hikers to walk the trail. Once someone clears a path in the forest and proclaims it safe, the first followers tend to tread lightly. But if a charismatic trailblazer proclaims, "You too can be like me," a bit too convincingly, followers stampede onto the trail with reckless abandon. And this is how you start a revolution.

As I said, Khloe's revolution empowered her target market to become her. There were many obvious imitators, and one such imitator released her own "story behind the pages" video, trying her best to look glamorous, yet relatable.

Kathie Lee announced herself online as a "blogger, writer, dreamer, and photographer." (Note that "photographer" came last.) Her script was remarkably similar to her well-known predecessor's. But instead of a 31-day journey, she announced a 40-day journey (a bonus nine days!) for those who invested in her book. While the "original" Rockstar said that her magazine "started as a crazy idea," Kathie Lee claimed to be "staring fear in the face and courageously setting her own path."

Rather than showing her in a high-fashion photo shoot, Kathie Lee's promotional video depicts her frolicking on the beach, brewing herself a cup of coffee, writing in her devotional book, and driving down an open road in a convertible (with a Mercedes Benz logo clearly obvious in the camera pan), feeling the wind whistle between her fingers. She pulls up along the beach, spreads out a blanket, and writes in her devotional book some more.

Again, nowhere in the video is she seen touching a camera. In fact, there's no camera at all anywhere in the video. If the sound were turned off, you'd think it was a commercial for a tooth whitener or a tampon.

But her promo delivers a more solemn message. Her journey to photography success is built on God's will. It urges members to join her Jesus-driven photography-success society. After all, "He promised in Chronicles 31:21 that if you work with Him, you WILL have success!"

There's only one problem, and it's a huge one. This gal was blasted (by the fickle internet crowd) two years earlier for claiming to have been so "blessed" to have a photography career that enabled her to pay off her home in cash. Had she not given a highly criticized workshop, (where she charged 20 women $1,500= $30,000!), the Internet pack might have let that one slide. But her claims of financial success seemed strange, and people got suspicious. Blogosphere investigators actually went to the county courthouse, and pulled up the title transfer records. And they posted their discovery online. She bought her house for one hundred dollars from her father.

This drew even more criticism, which emboldened other workshop participants to raise their voice a bit. After all, the workshop included, a "wear your little black dress and cutest heels party", a demonstration of how her associate "teases her hair", and having to witness an ugly fight between her and her boyfriend.

The more she tried to muffle the fallout, the worse that situation became.

She owned up to the miscue, complimenting the Internet detectives for their resourcefulness, and went under the radar for about two years.

Then, as the phoenix always rises, she resurfaced again with her new video. After the two-year "hiding" period, the majority of current photographers was brand new and had no idea about her previous fiasco. That was possibly the reason for her dormant period: to wait for a fresh crop of photographers.

You see, there is always a fresh crop. And that's how the fickle crowd can accept you back. It simply becomes a brand new crowd.

How Rockstars Are Created

The turnover for newbie professional photographers is amazingly rapid. A crowd of fresh faces arrives as often as the subway at 42nd Street in New York City. In the time it took you read to this sentence, two more "professional photographers" have probably appeared online.

Recently, at WPPI, the largest wedding and portrait photography convention in the world, a famous celebrity photographer asked the large crowd for a show of hands, "Who started up as a photographer in the last twelve months?" Half the hands went up.

The year before, he had asked the same question and had seen the same show of hands. Do the math. That means every couple of years, the bulk of the photographer pool turns over. And a great many of these newcomers are in search of guidance. As each new busload of passengers gets dropped off at the photography social network party, the first thing they want to know is, who are the leaders? Whom should they follow?

The problem is, they don't have any idea who is legit and who isn't.

It's perfectly understandable. If I wanted to start, say, fly-fishing, I'd have no idea who the experts were, so what would I do? A Google search. The people who would pop up first—thanks to search engine optimization (SEO)—might only call themselves experts. I wouldn't know. I'd just assume they were what they said they were.

So when new people enter the Face/Twit/Blogosphere

of photographers, the high-profile photo gurus who tweet a lot, ask for tons of "likes," and blog constantly have more visibility than the real people who are actually out there working for a living.

That's why people like Kathie Lee can resurface so soon after a disaster. She's now boldly touting her Jesus-centered success society (with a monthly fee that will assist you in seeking God's will for your photography business), and that's only possible because there are so many fresh faces who weren't around when the egg hit the fan for her a couple of years ago.

Really successful photographers—the ones who might actually have some valuable advice to share—have no time to tweet twelve times a day. They're busy having real careers.

The Mesmerizing Spotlight

It's seductive to think of yourself at a podium in front of a huge crowd. And it's tempting to fall in love with the public-speaking side of the business, even when you have very little experience at actual photography.

When you are in front of an audience for the first time, it is the most thrilling, yet nerve-racking thing you'll ever experience. Hundreds of people are sitting there with pens and notepads out. It's life or death on that stage, especially now in a Twitter-driven world. One person can say you suck and the other people in the room can instantly receive and retweet those tweets. Suddenly, 45 people leave the room at once and you get to watch them walk out as you're trying to hold your speech together.

It's stupifyingly scary. So when you're up there, the pressure is on to be really captivating.

That's where a lot of today's would-be Rockstars find themselves after making their way to the podium. The old adage, "Be careful what you wish for," couldn't be more applicable. You're standing up there, feeling completely naked, facing a bunch of people with Twitter broadcasters in their hands, ready to beat the crap out of you if you suck. Blow it for one minute and you can feel like Ashlee Simpson when the lip-sync track went live.

So you can't suck. That's why some seminar presenters — and I can totally see why this would happen — resort to making things up to keep the audience cheering and tweeting happy thoughts. In the end, if the audience stays through the whole thing and they applaud, you drink in a

flood of endorphins and are filled with ecstasy and re-
lief. Not only did you not get killed, but they actually
liked you! You rocked it. So what if you had to pad the
truth a bit to make it happen. It was worth it, for all con-
cerned.

Now put yourself in a convention where there's a
whole bunch of other novice speakers like you. The con-
vention floor is jammed with potential audience members
deciding whether to go to your seminar or somebody
else's.

In the weeks leading up to your workshop, you're hav-
ing nightmares about standing in a huge room with a tiny
smattering of people in it, with a microphone that feeds
back loudly, screeching its echo though a near-empty hall.
This is the deepest form of rejection one can ever face. So
what do you do? You tweet it up like crazy ahead of time.
You get sponsors to give you free products as giveaways
and you tweet about those too. You toss out little teasers
on your blog, offering tall promises of an "epic" experi-
ence unlike any other.

Oh, and you work on your program, too.

Do you want to talk about f-stops and shutter speeds?
Do you want to talk about how important QuickBooks is
to the efficient running of a business? Or would you ra-
ther talk about grander things? Like the inspiration you
get from Jesus and that voice that spoke to you in the
middle of the night that said, "You can do this!" Hmm,
yeah, that sounds like a lot more fun.

One year I was at a PPA convention having a banquet
dinner with some other medal and degree recipients. I sat

next to a guy from Bent Fork, Arkansas who took it upon himself to tell me how he was shooting a thousand weddings a year (in his town of 80,000 people), and charging $10,000 per wedding. I had to know where he was going with this, so I egged him on a bit. "Wow, so you're able to make $10 million a year!" When I threw that figure at him he looked totally befuddled, so I went on to ask, "Golly gee whiz, what's your secret?"

He tried to look collected and went on to tell me, "Well, my secret is this. You know when the ceremony ends and all the guests spill out in front of the church? I pull up in a big pickup truck and start throwing t-shirts to guests. Sometimes it causes a stampede—you'd be amazed at how people fight over these t-shirts! Pretty soon everyone's wearing my studio's t-shirts all over town and I'm booking all these weddings..."

He then explained that he was going to start giving seminars on his secret to success. My right eyebrow formed a tall arch and stayed that way for the rest of the evening.

All the same, I can understand what happened here. This guy was sitting next to some bona fide new PPA degree recipients and he felt on the spot, like he wouldn't measure up. So he went a teeny bit overboard in embellishing his accomplishments. The same thing happens with each new crop of Rockstars that spills out into the public.

You've got to make an impression on Twitter. And Facebook. It's a visual popularity contest and so everything counts. You have to stand out. You have to be cute. You have to say the magic things like, "Girlfriend, can we

talk?" You have to be "real." You have to be what you think they expect you to be.

But I hope you can understand that these people who want to fit in, to be seen, and to be admired, are playing to the same mentality that made Kim Kardashian a superstar even though she has absolutely no talent whatsoever.

Rockstars create a similar buzz. Their real talent is social networking. They whip up this hype that you, too, can be something amazing—that you, yes YOU, have the potential for greatness. You just have to unleash it. You just have to say NOW. You just have to say, "I'm going to go for it!" And it doesn't hurt to mention Jesus, and by the way, here's a handy online registration form (Visa and MC accepted), you too can lasso the moon!

As a new parent, this kind of fervor over surface appearances concerns me when it's this misleading. I'm not going to tell my son or daughter, "You are destined for greatness." There's a histogram for all things (not just digital imaging) and it applies to wealth, obesity, IQ, height, etc... Some of us will be exceptional, some of us will be far below average, and the great majority of us will be somewhere in the middle.

In all likelihood, my children will fall somewhere in the middle, and I won't demand anything different from them. I want them to be happy. I want them to be sweet, kind, and most of all, peaceful. So for me to tell them that they are destined for greatness? What happens when they get that first C- on a test they tried hard to ace? Will they be crushed? Will they doubt themselves? Will they spend years on the therapist's couch because they can't figure out what went wrong with them?

You have to say big things, and make big claims, lest the spotlight be taken away. Picture yourself in front of a big, fickle audience at WPPI as you tell them that, most likely, next year they'll be pretty close to where they are right now, career-wise. Picture what would happen if you told them that the world, according to you, is not much different from what they already know and observe. See how long you can keep them in their chairs with that kind of message.

You have to pump people up. You have to give them a really big, dynamic show. You have to give them their money's worth, and you have to entertain. You have to be fabulous, dress awesomely, wear the sequined top and the Louboutins, and profess to have amazing success in your core business (without being specific about your numbers, of course).

Of course, some hype is unavoidable if you want to fill seats. BUT—and this is a critical BUT—you must have something genuine to say or you don't belong on a stage. You must be a black belt in karate before you teach people self-defense techniques, or you will give them a false sense of "awesomeness" that will get them killed when attacked by an assailant. Likewise, students will be slaughtered in their dream of being a successful professional photographer if they learn from a false teacher.

The false teacher, who charges huge fees, is the lowest rung on the ladder of human existence. They are the scumbags of the world, no better than the spoiled milk at the bottom of a restaurant's dumpster. And yet we seem to crave these snake oil salesmen like we crave oxygen.

At the Wedding and Portrait Photographer's Interna-

tional (WPPI) convention in Las Vegas, a girl was recently heard to say, while leafing through the convention booklet trying to decide which speaker to listen to, "What is <u>she</u> doing speaking here? She's not even cute!" Wow.

Hear that metallic squeaking sound? It's the sound of the bar getting lowered once again. Now you have to be cute to get people in the door, and tell even taller tales to get your audience to not tweet against you.

So when you get up on that stage you're probably not going tell people they need to invest $12,000, minimum, in photography equipment. Or that they need to read their manuals from beginning to end and memorize all of the controls. Or that they should carry bags for a professional photographer for at least a dozen weddings before even considering becoming a second shooter. No, you're probably going to say, "Girlfriends! You can do it! Put the camera on P mode and spray and pray! Trust Jesus! Because you are destined for greatness!"

And if you're lucky, the crowd will go wild. The tweets will start leaping from the thumbs of excited audience members. And as fast as they love you, they can leave you.

There is one more thing to keep in mind: the parallel force of tweets coming from established photographers who know better than to trivialize the shooting of somebody's once-in-a-lifetime wedding. The undercurrent of angry tweets from established photographers demanding credibility for the profession have caused a huge split in a confused industry of constantly changing people.

Researching Your Instructor

There are many speakers out there with self-serving in-spirational seminars are what Texans would call "all hat and no cattle." So how do you steer away from the big hat guy?

Well, if a photographer or consultant/coach promises strategies that will lead you to success in the business of photography, it is absolutely fair for you to request proof that this person is actually a success.

After all, you have to follow such rules. We all do. When you apply for a job, for example, you're expected to fill out a job application. If any of the information you provide is later found to be false, this is ground for dis-missal.

So if you're going to hire a consultant or instructor, ask them to fill out an "application" form.

Here's mine for you to use freely.

Instructor Contact Information

Name(s) *[Last, First, Initial]*			Website	
Mailing Address	Street	City/Town		Province
Residence Telephone Number () -	Cellular Telephone Number () -	Business Telephone Number () - ext	E-mail Address	

Representation Of Instructor(s) Experience
if multiple instructors at workshop, please use one form per instructor

How Many Events Have You Shot Professionally As A Paid, Primary Photographer? How Many Weddings? Events _____ / Weddings _____ How Many Years Experience Shooting As A Primary, Paid Professional? _____	What % Of Your Income Is Earned From Shooting For Paid Clients? _____% % Earned From Seminars/Workshops/Educational Products _____%	Amount You Earned Last Year Shooting For Clients $_____ Earned In Your Highest Year $_____ *be accurate, do not estimate*
Amount Of Average Sale Wedding $_____ Portrait $_____ *be accurate, do not estimate*	Has Your Website Been Reviewed On FisheyeConnect.com? YES or NO	Do You Represent That You Will Provide Training / Skills That Will Increase My Income? YES or NO
How Many Workshops or Seminars Have You Given? _____ Have you EVER made representations in your marketing or communications that were misleading or false? YES or NO	Have You Presented At Any Major Photographic Convention? YES or NO	Please List Sponsors And The Compensation You Will Receive For This Program (If Tradeouts, Disclose Fair $ Amount)

Optional: Contact Information For Previous Paid Students (Not Relatives Or Friends)
not required for photographers who guarantee privacy for clients, but preferred

You can download the complete form, for free, at:
http://tinyurl.com/garyfonginstructorapp

With all of the "fluff" workshops out there—I'd say workshops with quality instruction are now more the exception than the norm—I'd suggest that you not attend any event without this form to protect you. If the instructor is honest, he/she will have no hesitation filling out this form. It's the ones who don't want you to know their an-

swers that will resist.

After the workshop, if you find that you have learned nothing, or that the instructor exaggerated claims of their own success, you now have something you can take to an attorney for a potential lawsuit. Most workshops allow students to remain in contact with each other, so if you all feel burned by a dishonest speaker, you can split the attorney fees in a multi-plaintiff lawsuit.

Review Instructors On Fisheye Connect

Information about a speaker or workshop's reputation can easily be gained on the Internet. Do a thorough Google search on the speaker and you'll get an idea about their experience in the industry.

Fisheyeconnect.com (FEC) is, at the time of this writing, the only seminar organizer that discloses online reviews from past participants. This can be very helpful to you. Think about eBay for a minute. EBay began with a farfetched proposition of brokering the sale of second-hand items online, with no guarantee (before it acquired PayPal) that the transaction was safe. What made it work was ratings and user feedback. You had to have good user ratings or no one would buy from you. This system of allowing people to report their feedback after each transaction eventually took hold, and once it was on solid ground, people felt safe to conduct sales transactions with strangers.

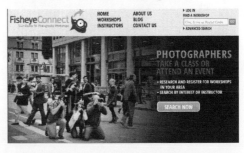

FEC is the first seminar source to start a rating system. (I have no financial interest in Fisheye Connect whatsoever.) Fisheye offers not only ratings, but a review forum to leave feedback for future attendees. You can preview an instructor's ratings and history with past attendees before deciding to sign up for a seminar. This is a win-win for everybody. It makes the instructor really work hard to have relevant, valuable content. It gives prospective students a due-diligence tool to use before committing, and it gives the industry itself a chance to weed out charlatans.

I envision a future where awareness of FEC is so broad that signing up for a workshop outside of FEC would be considered as risky as prepaying for an item on Craigslist.

The Honor Of Teaching

It is ironic that there are more "get rich" seminars than ever, yet we live in an era where the average fee for wedding photography has plummeted. Reaching a mega-level of success in wedding photography is much harder than it's ever been and yet these workshop presenters would have you think the opposite is true.

Please, you "poser" seminar leaders, heed this: Teaching is a prestigious honor and shouldn't be taken lightly.

If you're going to teach self-defense techniques you'd better be a black belt. If you don't know what the hell you're talking about and you give seminars claiming to teach people how to "fast-track" themselves to Ninja status, and they get killed because they're overconfident, whose fault is that?

Yours. You own that one. You just participated in getting somebody killed.

Somebody's son or daughter, or mother or father, is now dead because you were so full of crap that you made the person think they could fend off any enemy. And they couldn't.

Years before he died, my mentor Rocky Gunn gave me a piece of advice that I'll always remember gratefully, "Never fall in love with fame." He said that one year you may be speaking in front of a thousand cheering fans, but if you let it go to your head, you'll be crushed when only two hundred show up the next year.

He told me that the numbers don't matter. Being a

teacher is one of the most honorable positions in the world. Whether you're teaching a young child how to tie her shoes or a brain-injured person how to hold a fork again, teaching should be carried out with honor and respect for the profession and the student(s).

I was 23 years old at the time and had not even shot my first wedding, nor did I think I would ever be in a position to be lecturing a huge crowd. I don't even know why the conversation came up, but it left an indelible impression on me.

I remember one time Rocky was scheduled to give a seminar in Hawaii, and due to an error on the brochure printing, only one person signed up for his program. He was in Los Angeles at the time, but he still packed up all of his slide projectors, carousels, and photographic equipment, and flew to Hawaii to give an eight-hour seminar. He stood there next to a big projection screen, presenting his seminar to one man sitting in a chair.

How many of today's Rockstars would do such a thing?

I asked Rocky later why he didn't just reschedule, and he explained it wasn't that man's fault that no one else showed up. "If there is one student searching for a teacher, it's my duty to be there. In fact, it is an absolute honor to be there."

Rocky died at the age of 42, and I'm truly sad that today's wedding photography industry will never get to know who he was as a leader.

There is no bigger responsibility on this great earth than being a parent. You take on the care of a human being

who trusts you, is vulnerable, and totally relying on you for help. The next most honorable thing you can be is a teacher. Just because you didn't give birth to your students doesn't make their hearts less open, their minds less eager, or their spirits less trusting of you — their teacher.

They trust you. Why is it worth it for you betray that trust?

The Crash of the Wedding Photography Market
What Happened to Prices?

The workshops gurus would have you believe you can make a fortune in wedding photography, but this is really tough to do in the new millennium.

Prices for wedding photographers began to tank around 2006. Digital cameras began dropping in price as their features and automation options began expanding. I saw the revolution coming. In 2000, I witnessed something that would dramatically change the direction of my life.

I was shooting a wedding and, at the time, I was playing around with one of Kodak's earliest digital models, the Kodak DCS520. This was about a $12,000 camera with a huge battery pack that gave the outfit the weight of two bricks. The sensor was terrible, and it only shot in RAW. The price of a CF card was nearly $1,000 for 512MB; back then they were called Micro-drives. These were CF card-sized hard disk drives that actually had a little spinning disk inside them!

You could hook these cameras up to a printer and deliver instant 5 x 7 prints. They were made more for stationary event photography, like corporate meet-and-greets, or taking photos with Santa. In those situations, with flat studio lighting and no exposure surprises, they worked just fine.

But not at weddings.

Anyway, I noticed one of the guests had a small point-and-shoot camera. She went up to the wedding cake and

took a shot. She reviewed the result on her screen, frowned, and moved over a few feet. She took another image, frowned again, and moved a few feet more. Took another image and then her face lit up. Excitedly, she shared her LCD screen with her friend who said, "Wow! That looks so good, it could be in Martha Stewart Magazine!" Seeing the glimmer in the point-and-shooter's eye, I also saw a huge change in wedding photography coming right around the corner.

Right around this time, I remember the CEO of Kodak, Daniel Carp, saying that the film business was doing really well and was expected to continue doing so in the future. He discounted the possibility of digital photography wiping out the film and paper business. That attitude resulted in Kodak's bankruptcy less than a decade later.

As for me, I went into the lab business, through a company called Pictage. I figured that all of these digital photographers, whether newbie or established, would need prints. I had purchased lab equipment that allowed you to scan your negatives into high resolution files (unheard of at the time), so we could upload display images connected to a server, and allow internet ordering *without negatives*. Nowadays, of course, the original Pictage business is no longer innovative, and print sales are a small fraction of what they were then. This is because of a phenomenon called "shoot to burn" (shoot the images, then burn them to DVDs—I'll talk about this more in a minute).

For the wedding photographer trying to make a living, though, we might have called the phenomenon "crash and burn."

In Los Angeles, Holly, (my best second shooter ever)

can't make a full time living off photography. She really knew her camera operation inside and out, as she was a graduate of a prestigious fine art college with a major in photography.

When I closed up shop, she went out on her own. By then the market had gotten so competitive that, even with her talent, skill and experience, the most she could get for shooting a wedding was $500 for the day, which included giving the client an unedited DVD of original images.

The peak of the wedding photography business hit around 2001-ish. We knew digital was going to change things, but we didn't know it would do so much to lower the bar of professionalism.

What Caused the Ever-Plummeting Prices?

A few basic factors caused the drop in wedding photography fees from the typical $3,000 minimum price of a decade or so ago to about $500 today. They are:

1) **Learning From Inexperienced Teachers**. We've been discussing this at length. Novice photographers are not only shooting important, once-in-a-lifetime events (like weddings), but they are also charging big bucks for workshops on how to enjoy Rockstar success in wedding photography. Instead of teaching photography and business skills, though, they're teaching happy-sounding self-actualization and branding techniques that encourage people with little experience to throw themselves into the world of professional photography. As a result we have a lot of people out there with cameras who don't know what the hell they're doing. Hearken back to the horror stories I shared earlier.

2) **Too Narrow Of a Professional Divide**. Digital images are everywhere and most potential clients can't tell the difference between the work of a seasoned professional and that of a novice. That woman I mentioned earlier who thought she could publish in Martha Stewart Magazine, was probably so inspired by her cake shot that she briefly considered going pro. And the sad thing is, with very little effort, she could. Armed with a modest D-SLR, she could sign up for one of the many shooting workshops (where the instructor hires,

lights, and poses a professional model for the students to shoot), snag some great images from that, purchase a website from one of the many website companies offering ready-to-publish photography websites, and start booking clients. It is that easy to look professional. And it's harder than ever for a layperson to tell the difference.

3) **Camera Program Mode**. The advanced autopilot features of the new cameras make photography look deceptively easy. But Program mode is like auto-correct spelling on your cell phone. If you don't know how to spell, you won't know if the device guessed right or wrong. And you wouldn't know how to fix the error if it did guess wrong! Program mode gives an untrained photographer a misleading sense of confidence. It makes safe guesses that fail to stretch the equipment anywhere near its limits of creative expression.

4) **Fear of Justifying One's Pricing**. As photographers look around on Craigslist and see their competitors practically giving their services away, they become more and more reluctant to ask a living wage. They start reducing their own prices to be competitive. We'll talk about pricing in more detail later in the book.

5) **Trying to Look Exactly Like the Competition.** Here's a career-killing phrase I often see: "I can shoot exactly like [insert name of big-cheese photographer here] but at a much low-

er cost!" How about having a unique look that is all your own at a price that's fair to you? If you're cheaper than the photographer you are trying to copy, eventually somebody is going to copy you, and prices will go even lower.

6) **Shooting in RAW**. RAW images are exactly what are captured by the camera's sensor, without any processing. Users can later adjust slider controls to change the exposure or high-light/shadow details of their images. To me, this kind of tinkering with images is bewildering, because today's digital cameras are so accurate in metering that huge adjustments ought not be necessary (I've never shot RAW). Shooting RAW, photographers gain a sense of security, thinking there is more room for error. Thus the phrase, "I can fix it in post." RAW cannot fix everything, though, as our Central Park photographer found out earlier.

7) **Photoshop Actions/Lightroom Presets**. Photoshop Actions and Lightroom Presets are basically recordings of specific software adjustments to an image. Kind of like on your iPod/iPhone how you can choose a preset EQ setting to suit your taste. Photoshop Actions and Lightroom Presets have become a booming cottage industry. Fellow photographer/entrepreneur Kevin Kubota has made literally millions selling Action sets to photographers—Actions with names like Hawaiian Punch. These images are very highly processed, much like using Instagram. So if you

screw up an image really badly, you can "funkify" it by dousing it with Actions. Kind of like dousing a bad piece of fish with tartar sauce. Because these heavy processing tweaks dramatically change an image, photographers tend to use them on every single image, making the effect the subject of the image. As in, Tarter Sauce Flavored Fish.

8) **"Shoot To Burn."** As mentioned earlier, this practice is a byproduct of digital photography, where a photographer shoots an event, then simply copies the images onto DVD and hands them over to the client. This is a popular option because the client can have unlimited use of the images, can process them with their own set of Actions, and can make an unlimited number of prints at Wal-Mart. This is also popular with part-time photographers because there is no post-production work required. Charging a few hundred dollars for a straight eight hours of time, with no editing, the photographer can earn roughly $75 an hour. There is no mystery why Shoot to Burn is so popular. Easy in/easy out.

When I was a boy building model racecars, the first thing I would do is stick decals on the car. If they gave you 200 decals, I would use all of them, until the little car was completely plastered over. This is similar to the overuse of image processing. Once you start doing it, you feel that your un-goofed images look comparatively boring, so you have to punch them up with Hawaiian Punch. It's like giving makeup to a little girl. After she's gone to town with it, you can't even see her real face anymore; all

you see is the makeup. Same with Photoshop actions. If the first thing you notice is the effect, and not the content of the image, you're wearing too much rouge, my friend.

Aged Film is the current fad effect on the Internet. By the time you're reading this, that fad may have changed to something else. A short while ago, Selective Coloring was all the rage—where the bouquet of roses would appear in color, but the rest of the photo would be processed to black and white. Those images are rarely seen now, as that look is now widely ridiculed.

Trends come and go as quickly as Rockstars on the Blog-O-Net.

Back in the film days, there was a horrific period when everyone was using special effect filters on their lenses. Lenses like Tobacco Sunset would create a horizontal gradation of brown/red color to clear. The "star filter" (which came in four, five, or six-pointed star, your choice) brought a new crowd of hobby photographers to freeway overpasses to shoot car headlights, thus turning the freeway into a constellation. That wasn't photography, this was playing with a toy. So is the overuse of presets.

What does all this amount to? Well, for one thing, the typical expected cost of a wedding photographer, which was in the $3,000 range a handful of years ago, has now shrunk closer to $500.

While it was possible to become fairly wealthy as a wedding photographer up until around the year 2000 (many of us were making more than surgeons!), these days it's quite an accomplishment to make even a modest full-time living. But that is not the rhetoric of the new

workshop. Rockstar seminar leaders are out there promising unrealistic outcomes. And who suffers for this? Their attendees and the general public. Armed with a false sense of confidence, these unprepared, inexperienced photographers find themselves in situations far beyond their skill or experience level and create disasters like the ones at the beginning of this book. They then leave the profession, posthaste, only to be replaced by two more eager, ill-trained wannabes.

But there is hope. You can still make a great living as a photographer. There are still clients out there who want quality work and can see through the chatter. But if you want to be one of the few photographers that lasts, and that commands the decent fees, you've got to be the real deal. You've got to have the proper training, experience, and equipment before you take that first deposit.

Here's my suggested roadmap of how to become a true professional.

Forging a Real Career in Today's Market

So now I'd like to share with you my antidote to the Rockstar virus. The advice I am going to give you may not carry the romantic ring of Rockstar riches, but it will help you build a real business and put some black ink on your bank account statements. If this kind of success is more appealing to you than "learning to be the Photographer you were meant to be," then I cordially invite you to read on.

I left wedding photography nine years ago and have long since begun another chapter in my life. But I remember how hard I worked, five weddings in one weekend! I shot over a thousand weddings and did pitch meetings to at least three thousand potential brides and grooms. I've had to listen to "It's A Celebration", and "The Funky Chicken" from countless blaring DJ speakers. I built a business from nothing and earned millions from it.

When I started out, I worked day and night in the bedroom of my parents' tiny apartment. My room doubled as my office. I started with my $254 in savings and charged $150 to shoot a wedding. Many nights I went to sleep under my desk, dreaming about what I could do to make my products, services, and referrals stronger year after year.

The knowledge I gained from my mentor Rocky Gunn was pure gold, and so, when I began to enjoy success, I felt that if there were people out there who needed my help—people trying to improve their lives, or buy their children a better education, or reduce the stress of their day-to-day existence, I wanted to be there, full tilt, to help them. I was 100% ready to support and guide people away from devastating obstacles.

So I started giving workshops and seminars, but they were limited to my merchandising technique of pre-designing presentations for larger album sales. I wouldn't even know where to begin to give a lecture on pop spirituality. I don't read enough of the self-help books to know what whips up the crowd.

I still give a limited number of speaking presentations to photographers every year, and I never charge a speaking fee. It is an honor to be speak in front of any crowd, even if it's a crowd of four (my smallest ever; I could beat Rocky's record by giving an all-day seminar to zero, but that sounds really boring).

Since I don't teach much, I wrote the coming sections because I want to give you advice gained from twenty years of trial and error. Not overpriced, "inspirational" fluff that will empty your bank account but won't bring in any perceivable business.

For some reason I've become the Jon Stewart of this ridiculous madhouse that we call the new wedding professional photography industry. It's fallen on me to sometimes point out that a certain Rockstar/Emperor is wearing no clothes.

A lot has changed in photography since I left nearly a decade ago. Many of the things I was selling then may be a hard sell now, but everything was a hard sell then. So I won't make any guarantees that I have the magic solution to instant success, but I will share everything that worked for me, and you can extrapolate those tips into today's market.

If you follow the advice in this book, it will help you widen the professional divide between yourself and others.

Technology has moved so fast that it has put so much digital power, too affordably, in the hands of too many amateurs. And now they all think they have photography licked. But that's really an illusion.

The reason good wedding photographers made a lot of money in the days of film was that it took a huge leap of faith for someone to allow another person to photograph their wedding. With film, you wouldn't know if you had any problems with the pictures until the film was developed and the prints were made. That usually took about two weeks. I like to say that in the film days, photography was like playing the piano and waiting two weeks to hear the sound.

That was why people were highly motivated to hire well-rated "professional" photographers. A pro was trained and experienced and knew how to deliver technically sound images, consistently and reliably. I remember when I became a wedding photographer, people would often ask me, "What do you do if the pictures don't come out?" Honestly, that was the main reason people didn't go into wedding photography—they were terrified that two weeks after the wedding the photos wouldn't come out well. Those fears created a natural divide between amateurs and pros.

Digital changed all of that. With digital photography there was instant feedback. You could fix your goofs in real time. Sort of. And with that new ability came the illusion that anybody could be a professional wedding pho-

tographer.

The truth is, you still need a strong set of skills to succeed. And, as the horror stories in the beginning of the book show, there are still tons of things that can go wrong. But the workshops don't want to bog you down with that kind of trivia. They're too busy telling you that you can BE someone.

I want to combat that trend, so here are my best tips to those of you who seriously want to learn this profession. The rest is up to you. Fair enough?

Let's start out with some general advice on how to serve your "apprenticeship" and hone your skills, not only with a camera, but with people.

Shoot a Lot of TFP Models

When you're starting out, do a lot of TFP shoots. TFP stands for "trade for prints." There are a zillion aspiring models that are looking to add images to their portfolios. The trade-off is simple. You supply the photography, they supply the subject. You're both trying to learn your profession and you both need the practice, so it's a win/win.

Websites like modelmayhem.com are a great place to find this kind of talent. And they're not all runway models. There are models of all different shapes and sizes, and I suggest that you shoot as many different shapes and sizes as you can, as this will help you refine your eye on how to make everybody look good.

Even if you don't get any usable portfolio images from any of these shoots, having a camera in your hand, shooting as many subjects as possible, will give you invaluable experience. Every mistake you make in a TFP shoot is one you won't have to make when someone is paying you and entrusting you with their memories!

TFP sessions are cool because you're free to experiment. So press yourself creatively. For example:

Have your model run toward you so you can practice predictive autofocus (if you just said, "What's that?" you definitely need more practice), or have her whirl around at dusk with your flash on rear camera sync. Shoot a sports event. Find a restaurant that wants free food pictures, and light those with a PowerSnoot™. If you want to develop your lighting expertise, find a competitive bodybuilder, add some body oil, and try to create some spectacular samples. Find a little antique store that needs photos for

its website, so you can practice your macro "details" shots for color and selective focus.

On these unpaid TFP shoots, vary the conditions as much as possible. Try doing one shoot in an indoor location using only available light. Then schedule the next shoot in an outdoor location using fill flash. Schedule another shoot in an indoor environment using studio or flash modifiers. Give yourself as many versatility assignments as possible so that by the time you hang your shingle, you'll be really confident in a wide variety of situations.

Most of all, shoot, shoot, shoot. If you don't enjoy shooting for free, then you're definitely going into the wrong business.

Spend hours and hours in front of live subjects, getting familiar with a spectrum of temperaments and personalities. Your "clients" won't be expecting a great job or great customer service, because most people who shoot TFP are very loose with their customer service skills. Stand out by giving your TFP clients fantastic service. They will be your first source of paid work!

A Busy Office Simulation

I would suggest filling your calendar with as many "trade for prints" shoots as you possibly can so that you get used to the routine of shooting, editing, retouching, and keeping up a reasonable production schedule — before you have to do it for a living. Being a professional photographer means that a very, very small amount of your time is spent behind the camera, shooting subjects. Most of your time is spent editing, retouching, packaging, and presenting images to your clients. If you schedule five TFP shoots per week, which will keep you busy enough with production tasks and "client" meetings to give you a great dress rehearsal in time management.

Gradually, actual paying clients will fold into your routine without much disruption will replace these TFP clients. In fact, the only thing that will really change when you substitute paying clients for free ones are that your bank account balance will begin to rise. Time management and client relations are just as important to learn as actual photography skills.

Does all of this sound like a lot of work? Does it sound like years of dedication, perhaps? Of course it does. You're learning a *profession*. People go to college for four years to stand in an unemployment line. Becoming a skilled photographer is a lot more marketable than earning a college degree and has a lot more potential. But it, too, requires an investment.

I've been in a lot of businesses in my life, and the best thing I ever had going for me was the knowledge that Rome wasn't built in a day. Patience is a tremendous business asset — taking the time to perfect, refine, hone,

and rethink strategies will make your business a lasting, bulletproof entity. This isn't the kind of sexy, "you can have it all" advice you'll get at a Rockstar seminar, but it's advice that will keep you shooting pictures long after the seminar crowd has moved on to a new career.

Shooting for Friends

Another way to start and expand your sample portfolio is by shooting friends. If you shoot family members, it doesn't tend to look professional enough. If you shoot "semi-real" clients who are seeking a low-cost alternative to a professional photographer, this could be troublesome. That's because anyone who contracts you to take photographs is a real client with high expectations, no matter how little you charge them or how much you tell them that this a special deal because you're "just starting out."

The other reason to shoot friends is because the best way to make your business grow is through referrals. So doesn't it make sense to shoot jobs for free, and then ask for referrals in return? I'll talk more about the importance of referral marketing in a bit.

When you're shooting an event for your friends, remember that communication is key. Don't ruin a friendship over unmet expectations.

When you're just learning your craft, offer to shoot the event as an "unofficial" photographer. Don't charge a fee, and don't sign a contract. Just say you'll bring your camera. That way you won't have a lot of pressure on you to do a perfect job, and they won't have any expectations of you either. You'll be free to photograph the session with both you and your subjects feeling happy and relaxed. As a result, you'll get exactly the kind of sample images you'll want to present to future clients.

If a professional photographer is also contracted to shoot the event, do yourself a favor by keeping your camera in its holster most of the time and observing how the

photographer works with the schedule, handles the pressure, and communicates with subjects during the event. Don't be slimy and take your own off-angle shots of their poses and call the work your own. Trust me, there is a world of difference between setting up a shot (finding a good background, selecting an area with flattering lighting, directing the poses, etc.) and nabbing a shot that someone else set up. If you tell potential clients that such work is your own, you're lying. The setup/posing is a major part of the job. So if you didn't do that part, don't imply that you did.

Once you become a professional photographer and you get approached to shoot weddings for friends, do it for full retail, under contract. Explain that you have only 52 weekends a year to make your living, and this limited inventory of dates needs to be protected for the health of your business. For the purposes of the shoot, treat your friends as you would any paying client. Because if you leave the boundaries unclear, your friends' list of things they want included in the package will just keep growing.

Let me share with you two stories from my own career.

The first one involves a childhood friend of mine. I had just started in the business but I was pretty successful in filling my calendar with paying clients. I had booked 49 weddings in my first year, which was amazing testimony to the strength of my desire.

But in the eyes of my friend, I was still the childhood buddy who had never showed any interest, much less talent, in photography. So I was invited to his wedding, as a guest, but was told to "make sure to bring my camera and plenty of film!" I told him that my book was filling up

and that I wouldn't be able to shoot his wedding for free. To that he responded, "Trying to skip out on my wedding, are you?" I said I wasn't. He demanded that I come with my camera and shoot the wedding, "or you're not invited!"

Foolishly, I knuckled under and shot the wedding. Afterwards, I told him that I was going to give him all of the film and a set of proofs and that he could do whatever he wanted with them — make prints, or albums, or whatever.

Well, as they say, "give them an inch and they'll take a mile." After I gave him the negatives and the proofs, he came back to me and said, "Well, aren't you going to make a book for us?"

I said, "Absolutely not. I shot the wedding for free, I gave you the negatives, and that's something I never even do for my professional clients. You can print out as many images as you want and make your own books, which will save you a ton of money." He and his wife got really angry with me and we didn't speak for about fifteen years.

The next story is about a best friend of mine from high school. We were so close that she was a bridesmaid at my own first wedding. When it came time for her big day, she inquired about my taking the photos. I told her that I was in a time-limited business and only had 52 Saturdays a year in which to earn my living. Because her wedding was on Valentine's Day, I would probably not be able to make it, because I'd most likely be booked elsewhere.

Of course, I told her, she could hire me to shoot her wedding. I urged her to not feel obligated to choose me just because we were friends, but I also pointed out that

because I knew her and her family so well, I would have a unique insight into what pictures to take, what moments were most important to capture, and who the important people were. If she hired me, though, she would have to do so at full price, and our photographic relationship would be completely professional, to the letter.

That got the awkwardness out of the way quickly. Once we had set the framework, the professional relationship was good to go from that point forward, and there was no gray area. No line in the sand that constantly got moved. If she wanted to buy something extra, the price was right there on the contract.

Not only did we stay close friends after the beautiful job I did for her wedding (and the really large order her family placed with me), I wound up photographing her sister and her brothers' weddings. Same terms and conditions. And each of those siblings referred their friends to me.

So I can't stress this enough. Shoot your friends for free—in exchange for referrals—when you're learning the trade. Once you go pro, though, do "friend jobs" in a fully professional context (if you want, you can give them a "friend discount," but make it very clear that from that point forward there will be no further concessions or discounts). There's nothing that tests a relationship more than fuzzy boundaries and unclear expectations.

If you do decide, as a pro, to shoot a session for a friend for free, make absolutely sure that the expectations are low and in writing. Make sure that they sign a model release. (Why? Turn on "Judge Judy" and you'll see former best friends suing each other in every episode.) If your

deal is to give them free prints from their session or event, make it very clear how many they get. Again, make the boundaries very, very clear, especially with friends.

You're going to have awkward conversations about your prices with both clients and friends during the course of your budding professional career. The one thing to re-member is that you must be extremely firm, but friendly.

Keeping firm boundaries is crucial. Because when peo-ple sense a little bit of wobbliness on your end with regard to pricing, they will ask you for a deal. The best answer you can always give is,

> *"My prices are based on an industry standard for photographers with my skill and experience."*

And that's all you need to say. From that point for-ward, the boundaries will be firm and they will respect you as a professional in an anxiety-free way.

This is such a big point that I want to repeat it one more time. Memorize this answer by saying it a gazillion times. When people ask for a deal, say, "my prices are based on an industry standard for photographers with my skill and experience." Change the wording to suit your personal style and taste, but make the message clear. The minute you lose control of your authority, all hell breaks loose. Think of yourself as a strict teacher or parent who, for the good of all involved, must stay firm and friendly.

Now that you're clear regarding expectations, it's time to rehearse, practice, read, drill, and do everything you possibly can to ensure that you do a phenomenal job of shooting. The opportunity to create display samples is

tremendously valuable to you. If you do a great job, you'll be able to show the work to potential clients well into the future. Once you set the stage to shoot your friend's session or event—even if the expectations are very low—do everything you can to become the best photographer possible within the scope of your limited experience.

Carry Bags (Don't Shoot Yet!) for at Least 6-12 Weddings

If you want to get into wedding photography, one practice I strongly recommend is "caddying" for an established photographer for a while before you even think of picking up a camera at a wedding.

Offer to assist a pro for free. Just assist, not shoot. They'll ask you to "say that again," thinking it's an offer too good to be true. After all, who wants to lug all those heavy lens bags and extra camera bodies around all day if someone else is willing to do it?

Your job, as you assist the pro, is to make sure he or she has all of the needed equipment within fingertip's reach to get the next shot or sequence. Play this assistant role for a while, building a strong working relationship with the pro. This will eventually lead to your shooting as second camera.

I had an incredible assistant once, Holly. She assisted me for about six months, not even asking to second shoot, just watching me and learning. And boy, did she watch. Whenever I needed a particular lens, I would turn around and she would have it right there in front of me. It was almost as if she knew what I was thinking, just like a great golf caddy.

When I would go inside the bridal dressing room, she would ask, "Short lens kit?" I'd nod, and the perfect lens would be slapped into my hand with the precision that a surgical nurse slaps a scalpel into the rubbery palm of a skilled surgeon. She knew that inside the dressing room, I wasn't going to need my 200mm f1.8 lens or my 70-200mm f2.8 zoom lens, I was going to need my super

wide-angle zoom and prime lenses, and my fast 50 mm to 85 mm primes. The long lens kits were reserved for situations such as ceremonies and cocktail hours, where I would hide in the bushes to capture spontaneous moments from a distance.

Holly was the perfect example of a great second shooter relationship. She began as an attentive assistant. She watched everything I did without interrupting by asking to shoot images for own portfolio. She did this for many, many events—quietly watching me, quietly striving to understand what I needed in order to do the best job I possibly could.

She was always silent and in the shadows but I could feel her presence right behind my right shoulder. I would never turn around and wonder where she was. By contrast, I've had other assistants who would be over at the bar talking to guests anytime I had chairs to move or batteries that needed to be swapped.

When Holly joined me as an assistant, she was already an experienced and established photographer. She had graduated from an esteemed fine art school and was highly skilled at shooting models and headshots. But she wanted to get into wedding photography. She was smart enough, and humble enough, to put herself in "student mode" to learn the ins and outs. As time progressed, I became more and more grateful for how amazing she was. She helped me become an even better event photographer.

One day, as I was going through one of my preflight checklists (I'll explain this later), I put her name on two of the cameras and handed them to her at the beginning of an event. She had graduated to second shooter. I knew

she had a great eye, and that she knew what I was looking for in my special "storytelling" style of wedding album. And sure enough, when I looked at her images, they were spectacular. Not only were they expertly shot from a technical perspective, but they also showed insight and what I like to call "open awareness"—a rare quality I look for in a good wedding photographer.

Eventually, she started to add her own little personal nuances to the work. These were shots that I wouldn't have thought of taking, like particular details of the food, or macro shots of the bows on the bride's shoes. Never once did she suggest that I should try these shots, she just quietly added them to our inventory. Our roles slowly switched over time and she became my mentor of sorts, aiding me in adding some popular types of image to my repertoire.

That was the one of a handful of instances where I had a tremendously productive relationship with an associate photographer or second shooter. And, truth be told, I've never had a real horror-story experience. But several of my photographer friends have.

We'll talk a little later about some of the issues you can run into with second shooters. For now, though, I'd like to look at some basic preparation and equipment strategies.

Safe Handling Of Equipment: Checklists and Equipment

One of simplest and most valuable tools I ever devised was my "preflight" event sheet. I created it specifically for shooting weddings. On this preflight sheet, I would have a checklist of everything I needed to do to prepare my

cameras and flashes for the event. For example, I would write down which CF card went in which camera (using label letters taped to each card), and I would make sure that the date and time clocks on the cameras were all synced to my watch. To the second. That way, when it was time to edit the images from all cards into one continuous flow, I wouldn't have time discrepancies, which would make the editing harder.

NAME OF CLIENT: _SMITH/JONES_	DATE: _1/1/12_				
DIGITAL EVENT IMAGE FILE CONTROL SHEET					
LIST CAMERAS USED (TYPE/SN#)	5D–116	5DmII–611	5DmII–401	D300–811	D300–612
CAMERA ASSIGNED TO: (initials)	MP	MP	MP	SS	SS
BATTERIES CHARGED BY: (initials)	MP	MP	MP	SS	SS
SPARE BATTERIES CHARGED BY: (initials)	MP	MP	MP	SS	SS
CLOCKS SYNCHRONIZED BY: (initials)	MP	MP	MP	SS	SS
RESOLUTION SETTINGS CHECKED BY: (initials)	MP	MP	MP	SS	SS
ISO SET TO AUTOMATIC OR 640 BY: (initials)	MP	MP	MP	SS	SS
SENSOR CHECKED FOR DUST BY: (initials)	MP	MP	MP	SS	SS
TONE/CONTRAST SETTINGS SET TO NEUTRAL BY: (initials)	MP	MP	MP	SS	SS
CARDS USED					
I.D. TAG (ENTER LABEL ID IN BOX)	A	B	C	G	H
* CARD FORMATTED BY: (initials)	MP	MP	MP	SS	SS
*note: do not format cards until next event as they are the ultimate backup					
ASSIGNED TO PHOTOGRAPHER (INITIALS IN BOX)	MP	MP	MP	SS	SS
POST EVENT IMAGE MANAGEMENT					
CARDS RETURNED FROM EVENT (INITIALS IN BOX)	MP	MP	MP	SS	SS
CARDS BACKED UP TO HARD DRIVE BY:	MP	MP	MP	MP	MP
ORIGINAL CARD BACKED UP BY DVD BY:	MP	MP	MP	MP	MP

PHOTOGRAPHER #1's INITIALS = SIGNATURE	MP	= Main Photographer	MAIN PHOTOGRAPHER
PHOTOGRAPHER #2's INITIALS = SIGNATURE	SS	= Second Shooter	SECOND SHOOTER
PHOTOGRAPHER #3's INITIALS = SIGNATURE		= PHOTOGRAPHER SIGNATURE	PRINT NAME HERE
PHOTOGRAPHER #4's INITIALS = SIGNATURE		= PHOTOGRAPHER SIGNATURE	PRINT NAME HERE

by signing above, each photographer certifies that all images taken at the event exist on assigned cards only. NO SHOOTING ON OTHER CAMERAS ALLOWED

IMAGE REVIEW AND CATALOGING		GOAL	COMPLETION	CLIENT CONTACT INFO
HARD DRIVE COPY 2 FOR WORKING SET (inits)	MP	1/3/12	1/3/12	213 555 1212
DELETION OF OUTTAKES (init)	MP	1/4/12	1/4/12	
IMAGES CORRECTED/RETOUCHED	MP	1/6/12	1/6/12	client @ hotmail.com
EDITED DVD CREATED FOR STORAGE	MP	1/6/12	1/6/12	
COPY OF EDITED DVD CREATED FOR SAFETY	MP	1/6/12	1/6/12	
COPY OF EDITED DVD CREATED FOR CLIENT	MP	1/6/12	1/6/12	

It is absolutely imperative that you use this "preflight" sheet on every event that you photograph professionally. I guarantee it will make your post-production treatment of files extremely safe and will prevent many of the second shooter issues I describe later.

This preflight sheet is simple, yet extremely detailed, and should be the center of your image management universe.

The checklist helps you prepare for your event as well. There are little boxes for each photographer (in case you are working with associates) to initial that the batteries are charged, the clocks on all of the bodies are synched, etc.

If you ever get sued, there is nothing more helpful than this sheet to show to the judge or jury. It demonstrates that you exercised professional diligence in protecting your client's files. You can't get sued for catastrophic accidents, but you can get sued for negligence by failing to exercise professional care. This sheet will surely save your ass at least once or twice in your career, so once you complete it, keep it in a fireproof safe—along with your saved CF cards. You will be very glad you did.

Other than the signed contract, which we'll talk about soon, my preflight sheet was the most important piece of paper in my client file. You may download the printable sheet and print it out for your own use at this link:

http://tinyurl.com/gfchecklist

If I charged you $500 for this template, it would be one of the most valuable things you ever bought—but I'm giving it to you free!

The use of this sheet is super important, but easier to explain on video than in typed words. I have three YouTube videos that explain how to use it. They're located at:

http://tinyurl.com/garyfongpreflightyoutube

This checklist sheet accommodates up to four photog-

raphers and five cameras, with up the three CF cards per camera. I only used one per camera. Why?

Safely Handling Your CF Cards

The safest place for your CF card is inside your camera. The camera will ensure that no dirt or liquids get inside the pins to corrupt the connection. The camera will keep you from losing the card, too. Most CF cards are lost because they fall out of a pouch or a pocket. This isn't likely to happen if you have one card per camera. Also, if you should drop your stuff, the camera serves as nice shock protection for the card. Furthermore, it serves as protection from static electricity, which can be created simply by rubbing your hands together on a cold day— you could touch the card and zap. Wiped.

Label your cards from A-Z (I used a label-maker for this). Then when you put your card inside a camera, use the sheet above to record which card went into which body (identified by the last 3 digits of the camera's serial number).

After you shoot the event—and this is really important—rotate your cards out of usage! For example, if during an event you shoot cards A-D, keep these cards out of circulation until you are certain the images are safe and have been backed up. Why? Because your original CF card is the ultimate backup. Often the inexperienced file archivist will make one copy of the images to a drive, and then start "editing" those images. Pretty soon the original images are missing or irreversibly modified. Or num-

bered incorrectly. Plus, how do you know that all of your files transferred properly to the drive without carefully inspecting each one after the duplication? Keeping the original cards as a backup, you will never have a problem with a crashed hard disk or backup error.

One photographer wrote me to tell me that he thought he had copied the images to his hard drive, so he formatted the CF cards. He later discovered that he had only saved "alias" icons of the files. So, when he clicked on the hard drive file, it asked for the original flash disk, which he had already formatted!

Suggested List of Equipment for the Professional

You wouldn't offer your services as a professional DJ if all you had was a crappy boom box, would you? Have you ever noticed the construction of the pro DJ's rack, equipment, and speakers? It's all rugged, military-grade, professional gear. Why is it made so hefty? Because lesser equipment breaks when it's not supposed to.

If you have a home treadmill, compare it to the one at your gym. They look the same from the outside (as does a Digital Rebel when compared to a 60D). But when you try to pick one up, the commercial one is many times heavier. It is built to withstand constant hard usage by a steady stream of exercisers, most of whom are substantially heavier than they want to be.

Professional gear is meant to last. Let's look at some camera equipment as an example.

What Is A Professional Grade Camera?

CANON	GOOD KIT	PRICE	BETTER KIT	PRICE	BEST KIT	PRICE
BODY #1	7D	$1,699	5Dmkll, mklll	$3,499	EOS1Dx	$6,800
BODY#2 (BACKUP)	7D	$1,699	5Dmkll, mklll	$3,499	EOS1Dx	$6,800
VERY WIDE ZOOM	10-22mm f3.5-4/5	$899	16-35mm f2.8	$1,699	16-35mm f2.8L	$1,699
RECTILINEAR ULTRAWIDE					14mm f2.8L	$2,299
NORMAL PORTRAIT LENS	50mm f1.4	$399	85mm f1.8	$425	85mm f1.2	$2,399
MODERATE WIDE ZOOM	17-40mm f4	$899	24-70mm f2.8L	$2,499	24-70mm f2.8L	$2,499
TELEPHOTO ZOOM	70-200mm f2.8L	$2,499	70-200mm f2.8L	$2,499	70-200mm f2.8L	$2,399
ULTRAFAST TELEPHOTO					200mm f2.0	$5,899
FLASH UNIT (#1)*	Nissin Di866 MkII	$329	Nissin Di866 MkII	$329	600ex-rt	$649
FLASH UNIT (#2)*	Nissin Di866 MkII	$329	Nissin Di866 MkII	$329	600ex-rt	$649
FLASH DIFFUSERS	FONG LSC	$59	FONG LSC BASIC KT	$149	FONG LSC PROKIT	$169
FLASH MODIFIER	FONG LSC	$59	FONG LSC	$59	FONG LSC	$59
TOTAL INVESTMENT		**$8,870**		**$14,986**		**$32,320**

NIKON	GOOD KIT	PRICE	BETTER KIT	PRICE	BEST KIT	PRICE
BODY #1	D300S	$1,699	D800	$3,300	D4	$6,200
BODY#2 (BACKUP)	D300S	$1,699	D800	$3,300	D4	$6,200
VERY WIDE ZOOM	10-24mm f3.5-4	$849	16-35mm f4	$1,295	14-24mm f2.8	$2,100
RECTILINEAR ULTRAWIDE					14mm f2.8D	$1,895
NORMAL PORTRAIT LENS	50mm f1.4	$395	85mm f1.8	$525	85mm f1.4	$1,795
MODERATE WIDE ZOOM	16-35mm f4	$1,139	24-70mm f2.8G	$1,995	24-70mm f2.8G	$1,995
TELEPHOTO ZOOM	70-200mm f2.8G VR	$2,495	70-200mm f2.8G VR	$2,495	70-200mm f2.8G VR	$2,495
ULTRAFAST TELEPHOTO					200mm f2.8	$5,995
FLASH UNIT (#1)*	Nissin Di866 MkII	$329	Nissin Di866 MkII	$329	SB900DX	$595
FLASH UNIT (#2)*	Nissin Di866 MkII	$329	Nissin Di866 MkII	$329	SB900DX	$595
FLASH DIFFUSERS	FONG LSC	$59	FONG LSC BASIC KT	$149	FONG LSC PROKIT	$169
FLASH MODIFIER	FONG LSC	$59	FONG LSC	$59	FONG LSC	$59
TOTAL INVESTMENT		**$9,052**		**$13,776**		**$30,093**

SONY	GOOD KIT	PRICE	BETTER KIT	PRICE	BEST KIT	PRICE
BODY #1	A65	$899	A77	$1,399	A77	$1,399
BODY#2 (BACKUP)	A65	$899	A77	$1,399	A77	$1,399
VERY WIDE ZOOM	10-24mm f3.5-4	$849	10-24mm f3.5-4	$849	10-24mm f3.5-4	$849
RECTILINEAR ULTRAWIDE						
NORMAL PORTRAIT LENS	50mm f1.4	$429	85mm f1.8	$525	85mm f1.8	$525
MODERATE WIDE ZOOM	16-50mm f2.8	$749	16-50mm f2.8	$749	16-50mm f2.8	$749
TELEPHOTO ZOOM	70-200mm f2.8	$1,999	70-200mm f2.8	$1,999	70-200mm f2.8	$1,999
ULTRAFAST TELEPHOTO	135mm f1.8	$1,599	135mm f1.8	$1,599	135mm f1.8	$1,599
FLASH UNIT (#1)*	HVL-F43AM	$349	HVL-F58AM	$499	HVL-F58AM	$499
FLASH UNIT (#2)*	HVL-F43AM	$349	HVL-F58AM	$499	HVL-F58AM	$499
FLASH DIFFUSERS	FONG LSC	$59	FONG LSC BASIC KT	$149	FONG LSC PROKIT	$169
FLASH MODIFIER	FONG LSC	$59	FONG LSC	$59	FONG LSC	$59
TOTAL INVESTMENT		**$8,239**		**$9,725**		**$9,745**

This is a current list as of July 2012. In an instant the model numbers on this list will be different, replaced with newer model numbers with more features at a lower price.

The cameras listed above are built to take the punishment of professional use. With metal bodies, rugged shutters and lens mounts, and additional weatherproofing, these heavier cameras focus faster in lower light, create bigger photo files with more accurate information, and offer the fast manual overrides that the pro photographer demands.

Also, these pro cameras are built to have long lives. An

inexpensive Canon Digital Rebel has a life expectancy of 50,000 shots (about 30 weddings or less) while the Canon 1D Mark IV offers 300,000 shots before failure. So if you're going pro, get the one body that will outlast six of the amateur bodies.

Here's my take on the Big Three:

1) **SONY** — The Alpha series is technologically ahead of both Canon and Nikon by quite a bit. The A77 has a 23-megapixel-image size, shooting at twelve frames per second. This is a larger sensor than the Canon EOS1DX (an $8,000 body) and is twice as fast as the EOS 5D Mark III. It has an electronic viewfinder that allows you to pre-visualize under/overexposure and custom picture modes (like black and white) right through the eyepiece. It also has in-body anti-shake technology and focuses amazingly fast. You can see the exact moment of exposure because there is no mirror to momentarily block the view between your eye and the lens. Lastly, the flash system and controls are amazing. The lenses include Zeiss T* glass (the same as Hasselblad), and, because of the APS sensor size (which I actually favor), you can purchase a 150mm f1.8 lens for under $2,000. Comparing this with a Canon 200mm f2.0, you get the same effective focal length, a bit faster, and at ⅓ the $6,000 cost of the Canon. (I use Sigma lenses. I find that Sigma's have a excellent range of lenses and fantastic build quality.)

2) **NIKON WITH SONY SENSORS (D5100 /D700/D800/D3x/D4)** — Having seen literally millions of digital images while running a large digital lab during my Pictage days, I can tell a Nikon image in an instant. The early Nikons were horrendous for blowing out flesh tones (color blooming) and were particularly troubling when shooting in open shade. The images were extremely blue, and even when shooting in RAW or capturing JPEGs in "open shade" white balance, the skin tones became an odd shade of "spray tan" that was impossible to fix to perfection. It was so bad that when someone stole my D2H, I didn't bother to replace it or report it to the insurance company. I couldn't use it anyway. Nikon couldn't really make sensors, but that has changed since it adopted Sony's sensor technology in some select cameras (listed in the chart). These cameras now produce beautiful images, and can hit six-figure ISO's with acceptable noise. Nikon would be at the top of the list with its great glass, but without an OLED sensor like the Sony, it can't focus as fast or help you previsualize different color settings or exposures. Oh, and the mirror will flip up during exposure, blinding you from the moment of capture.

3) **CANON** — For decades Canon was the industry leader in the pro photography equipment world. A few years ago, you needed only to look at the sidelines of any sports event, and you'd see mostly white telephoto lenses (a distinctively Canon characteristic). Nowadays you see mostly black (Nikon). Canon has long been

known for its excellent lenses, but recently on some models, there have been reported focusing issues. Their flash system (prior to the 600ex-rt) had a bizarre navigation system that involved holding the "Zoom" button for five seconds to access the infrared wireless functions. With the new 600ex-rt, having owned two of them, I've had intermittent success in getting them to fire with a hybrid infrared and radio system. This is another reason why I recommend Nissin or Sigma, or other third party flashes, such as:

THIRD PARTY FLASHES—The E-TTL technology in the camera is licensed to third-party manufacturers, such as Nissin, so you can be assured that the E-TTL exposures will be as accurate as with the name-brand flash. Nissin's Di866mkII flash offers a good build quality (not as good as the original party manufacturer), but the navigation with a large color LCD and hierarchical menus gets you to the functions you need without memorizing quirky steps.

GARY FONG LIGHTSPHERE COLLAPSIBLE— When I was shooting professionally, I rarely shot without flash. The shots that I did with available light were beautiful, but available light is only usable in limited situations. You can't use it if stray light hits the subject. You can't use it if there's too much light coming from above the face, making the eye sockets disappear in the shadows. And of course, you cannot use available light when the light is so low that it would cause noise or blurry motion. Flash photography is typically really un-

flattering because the flash unit is right over the lens, and the flash head has the same shape as a car headlight, complete with a parabolic reflector inside. This makes human subjects look as if they are about to be killed by an oncoming truck.

I designed the Lightsphere after having seen so many bad digital images when running the Pictage lab. Many of them had blown out faces and highlights. I knew the problem was the position and shape of that darn lamp-head.

I found the inspiration for my product from another lamp-head: a living-room lampshade. I noticed that whenever you are in a room at night, the room is beautifully lit, as are the people in it. The reason lampshades are used in interiors is that they spread light all around a room evenly. They're open on the top, and the sides provide a soft, even illumination that mixes nicely with the light hitting the ceiling.

An analogy would be the standard hose attachment a gardener might use. There are different settings, from "jet," which can spray the leaves off a walkway, to "mist," which one would use on a rose bush, so as not to blow the petals off. The Lightsphere is like a fine mist; your flash unit without it is like a regular hose.

The Lightsphere diffuses the flash. Diffused flash ensures that your images are more consistent. With flash, you get consistent light quality and with a Lightsphere, it's hard to tell that the flash is even being used. This is why you see them in use

everywhere. They work great. I didn't write this as a plug for my product, I wrote it as a photographer.

I design products that I know I need, but are not yet available in the market. If I hadn't invented the Lightsphere, someone else would have, and I'd still be using it and writing about it here. (If you are interested in the mindset of an inventor, see my other book, *The Accidental Millionaire*.)

Must I Spend A Lot Of Money on Equipment?

I honestly think that a lot of the motivation for people to buy expensive gear is to look professional and to be "part of the club." This is probably why the Canon 70-200mm f2.8 "white" lens is featured in so many profile photos on Facebook. It looks cool and "serious."

I asked a student photographer why she had an expensive Canon L series 50mm f1.2 lens on her inexpensive Digital Rebel. Her answer? "I want to look professional".

My family lives on a horse ranch where we host weddings and corporate events. It's where my wife Melissa and I got married. So I see photographers bringing in bulky but "showy" gear that is over the top and not really used properly.

There's no point buying equipment that's more than you need. On other hand, there's even less reason to buy cheap gear—like the under-$1,000 camera with the 18-55mm f3.5-5.5 kit lens. That stuff breaks. The lenses are slow to focus, dark, and have chromatic aberration (color fringing at the edges). They don't respond well, they

don't calculate well for exposure, and their modes are very middle-of-the-road — safely automatic but creatively limiting.

If you think being a professional photographer can get you a Rockstar lifestyle, including world travel, adoring crowds and a tour bus, then surely it's not unreasonable to invest between $9,000 and $30,000 for the most important part of your company, the photo equipment. It's still a relatively cheap investment. After all, to buy any other kind of business, like a donut shop or hair salon, requires a deep six-figure outlay.

Is it truly realistic to think one can spend under $3,000 and suddenly live the life of Lady Gaga or Justin Beiber? The answer is yes, according to many of the workshops and photo success/self-actualization blogs. But in the real world, the answer is no.

If you want to be a pro, not only do you need good, pro-quality gear, you also need to do the unromantic work of getting your papers in order. That's what we'll talk about next.

Getting Documented:
Simple Guide To Necessary Paperwork

When starting out in business as a professional photographer, there is a certain order you have to go through when putting together your paperwork. It is a bit tedious, but completely necessary to spare you of a ton of grief.

The first thing you have to do is get a "fictitious business name statement." Even if your name is going to be "John Doe Photography" you'll need to get a so-called DBA (Doing Business As) so that you can create a completely separate business checking account for your business.

Just go on Google and look up how to get a fictitious business name statement for your municipality. What is usually involved is that you have to publish your intentions to use this name in a local paper that does legal announcements. (This usually winds up next to the obituaries, etc.) The paper will publish your intended use of the business name for about a week or so, and then they will send you a stamped form certifying that you published your intention. Who ever reads these notices? No one. But the idea is, you have to give the business community a chance to object, in the rare case that someone else is already using this name or there are other potential legal issues with the name.

Take this stamped paper to your local bank and open a business checking account under your new company name. You have to have a separate account. You can't just put money from your clients into your personal banking account, because all of your deposits will be under careful scrutiny in the case of an audit. All of your busi-

ness expenses should come out of this special account, and all of your receipts for your photography services should go into it.

Next step is to get a sales tax ID number. You need a retail sales tax ID number because whenever you sell products within your state (if your state is one that has a sales tax), you're required to collect and remit sales taxes, along with a quarterly return. So you really have to get this right. You need to add sales taxes to your invoices and keep records of those invoices. Every quarter, you need to send the state government a check for the taxes you've collected, along with a filled-out return.

This is super important and could save you from disaster. When you charge a shooting fee and there's any tangible product (e.g. photos) exchanged, you absolutely must charge sales tax on the shooting fee, even though that's really a service. Here is the reason: imagine a Chevrolet dealer charging you a $30,000 service fee for assisting you in obtaining a car, and then charging you $50 for the car. That would be great for you, because you would only pay sales tax on $50, but it would be really bad for your regional government. Everyone would take advantage of such a loophole.

One of the first studios I trained with went ten years without charging sales tax on their wedding es. They charged $500 for a combo package that included their photography services and a few prints, but they didn't add sales tax. After ten years, with interest and penalties, the tax liability for this studio was tremendous.

If you are a dentist or a massage therapist, then your work is considered a service. But when your package includes any product, anything tangible, you must add sales

tax, collect it, and forward it to the state.

Setting Up a Corporation or LLC

The common advice for any wedding photographer or event photographer is to make sure you are incorporated or have an LLC (Limited Liability Corporation). This is a good step, but it doesn't solve every problem and it creates some problems of its own.

First of all, if your company is incorporated and you lose a lawsuit that results in an order against you, it is possible for a collection process to seize your further earnings.

Also, the cost of incorporating or forming an LLC is typically in the four figures. And that's a lot of money for many people starting out. Then there is the matter of the annual taxes. In California, for example, it's a minimum of $800 per year regardless of what your earnings are. That's a fair bit of money for most photographers starting out, and it seems like those twelve months whiz by like lightning when you have a recurring bill like this.

On top of that, you need to buy liability insurance. And the minute you form a corporation, your personal policy ceases to protect your corporate assets (even if you have an umbrella clause that protects you from any possible liability). Let me put this another way, because it's worth repeating. Let's say you are found liable for damages. Even though your corporation may have no assets, a judge may order you to keep shooting weddings, delivering albums, and providing all of those profits to your plaintiffs through your corporation until your debt is paid off.

Therefore, you absolutely must purchase corporate liability insurance. This is a expensive even if you are earning a fair amount of money through your photography fees.

Accounting Setup

Another thing I'd like to touch on is QuickBooks. It's super important to get the QuickBooks software program as soon as you get that first checking account open. For the light user, I'd recommend QuickBooks online as an inexpensive (monthly fee-based) solution that works really great. Also, if you can, hire an inexpensive bookkeeper for a few hours a month.

Take photos or scans of the receipts for every expense related to your photography business, and e-mail those photos to a special e-mail account that only holds pictures of your receipts (e.g. "yourbills@gmail.com"). Now you have your audit trail completely intact, you have your business finances separated from your personal finances, and you have easily searchable backups for all of your receipts in case of an audit. You've also made it easy to track how profitable your business really is.

Even though it seems like this planning and paperwork is fairly involved and detailed, it's easy to keep up with once you've established the system. In truth you can probably get all of this paperwork done in half of one working day per month, or less.

You're going to need all of this together so you can invoice your very first client for their very first paying order with you!

The All-Important Contract

There's one more piece of paper to discuss. Before you shoot your first professional gig, you're going to have to settle on the contract language you will use with clients. This will evolve as time goes on, but you want it to be as thorough and clear as possible, even with your very first client.

I hope you realize that I can't give you a sample contract here because I'm not a lawyer. Giving you suggested wording for your contract would be legal advice, and I can't offer that. I often see sample contracts for sale on the Internet, for, like, $30. This baffles me. Every jurisdiction has different laws, every individual has different things to protect. Contracts are not generic enough for general use.

The vendors of contracts will add a disclaimer like, "This is just an example—check with your lawyer." And my question is, example of what? A legal document, which when signed by both parties makes each party bound by what it says. So if the contract leaves out important things like maximum liability, and you lose everything because somebody sold you a crappy $30 contract, call a lawyer and try to get your damages back from the buffoon that sold it to you.

Anyway, call around for civil law attorneys in you area until you find one who's done a photography business contract before. Offer a maximum $500 fixed fee, and you'll get a one-hour interview, followed by one hour of the attorney's time to write the contract.

In the contract, make a list of what you charge, what's included in your fees, and what's not included. This is

called a consideration section. It's where you define the exchange you're about to make. So it would say, "For valuable consideration received..." and there would be a dollar amount, and a list of what the client gets for that money. Again, list everything you can think of, such as travel expense costs for events more than 50 miles away, and how you will be reimbursed for these. (Will you charge a flat fee or will you supply receipts and have your reimbursement due within 30 days, etc.)?

How many album design meetings will you include in your plan? How much will it cost for each additional album design session?

At what megapixel minimum will your photo files be captured? What are your criteria for a "usable age? (Example: I define a "usable image" as an image in focus, exposed so that flesh tones are not blown out, with shadow and highlight detail visible.) You want to narrow down what an acceptable image is so that nobody sues you for "doing a bad job." Describe the images you promise to deliver in technical terms, not "subject or content" terms. This is how you avoid being sued for "not taking enough pictures of me smiling." And have clear language that says that these are the SOLE CRITERIA for acceptable images. Try to avoid committing to a minimum number of images.

Your attorney will make sure the contract protects you from a civil liability angle. Also check for the following items:

1) **Copyright**—Wherever and whenever your client wants to publish your image on the Internet, your copyright logo must be visible to the unaided eye,

placed directly on the bottom third of the image.

2) **Maximum Liability**—Make sure that your maximum liability for anything that happens in this relationship is limited to a refund of fees.

3) **Replacement Photographer**—Have your attorney word something that protects you if you get sick and have to provide a replacement shooter. Include language that the replacement will be a photographer who has been shooting for a specified period of time, and/or for a specified number of events. That keeps you blameless for not providing somebody "as good as you"—that's far too subjective a definition for a lawsuit.

4) **Hold Harmless or Indemnify** for Publishing Images of Your Guests—Your lawyer can decide if he/she wants to add this clause, which would make your bride and groom— not you—the parties to sue if one of their guests wanted to sue for unauthorized use of their images.

5) **Right to Reproduce Images** at the Event Without Prior Authorization and for Any Use—You want to be able to use the images for your own business purposes, including but not limited to: advertising, promotion, educational purposes. The "not limited to" phrase would come in handy if something totally outrageous happened, such as Bigfoot showing up at the ceremony, and you wanted to sell the photo to a news agency. By adding this clause, the client gives you blanket permission to use the images.

The contract is the most important document in your studio. If you get sued, simply bring the contract and your preflight checklist with you to court, and you will have everything you need to show the judge.

Oh, and buy a fireproof safe and keep the originals in there. Or not. It's up to you.

Documentation Costs

So by the time you go out and shoot one paid event, you've probably invested $3,000 or more in legal and insurance papers. And you won't get this money back if you decide to quit. You've also sunk many thousands into your photo equipment and, although you could sell it used on Craigslist, you'll take a major hit.

This is why it's super important to be sure you want to do this. Carry bags for a number of events first, to see if you even like the profession. Then, after doing this maybe a dozen times, you should have a good feel of the pace and pressure of the event. Ascertain if you have the personality (and desire) to lead an event and direct a group of people all day long. Then begin second shooting, to see if you have any talent behind the camera.

Once you've passed all of these tests, then I would say it's time to make that multi-thousand dollar investment in setting yourself up as a business.

And once you do that, you're in a whole new world. Now it's time to make money, and start generating referrals. You're going to need to be successful in the business of photography — and that's far from easy. It's kind of like baby turtles being born on the beach. Hundreds of them hatch from eggs, but only a few of them make it to sea. The rest of them, hate to say it, get eaten or give up.

We'll talk about how to set your fees and how to get clients and referrals in just a minute. First, though, let's look at some of the issues that can creep up around second shooters.

Second Shooters
Working as and with a Second Shooter

As I mentioned earlier, serving as a second shooter is a super way for photographers to gain experience and collect sample images. What the primary photographer gains from the arrangement is a back-up cameraperson to capture additional angles and shots, and, of course, to carry the bags around. Also, it is a selling point for the experienced photographer to tell their client, "There will be two-person coverage" during the event.

I recommend putting yourself in as many second shooter situations as possible (after you've served your bag-carrying apprenticeship). It's an extremely important part of training. By watching pros work, you'll learn new posing techniques and lighting techniques, some of which you will embrace and some of which you will reject. But that's all part of defining your own personal style and technique.

There are some tricky issues to be aware of, though, when it comes to second shooting.

Typically the second shooter shoots for no pay, just experience. Often he or she also gets some high-resolution copies of images. Without such sample images, it's very difficult for a starting photographer to show any examples of professional work. But second-shooter shots are not a true representation of what that photographer is capable of, because he/she was simply a spectator with a camera. There is a world of difference between simply snapping shots and dealing with bride psychology, handling groups, directing poses, and organizing an efficient shooting schedule.

For the established photographer, giving out high-resolution images can be dangerous. Here is an absolutely true fact of law that can't be denied: the moment a person snaps a photograph, that person owns the copyright to that image. What does that mean? That means that the copyright owner can dictate what happens to that image, without limitation. This can create a real problem for the primary photographer. Say, for example, a photographer shoots a wedding along with a second shooter, but does not separate who shot which images. Under most countries' federal copyright laws, the person who actually shot the image can say, "I don't want you to use any of these images for any purpose whatsoever." It is completely legal and permissible for the second shooter to demand this.

Most people assume that the second shooter cannot use any images he shoots at an event without the primary photographer's permission. Not so. It's really more the other way around. Even if there's a contract that specifies that any images shot at the event "belong" to the studio photographer, usage is the crucial factor. Although the established photographer can keep the high-res images as her sole and separate property, that does not negate the second shooter's rights to demand that the images not be used. The second shooter can prohibit the primary photographer from using the images as displays, in a bride's orders, or on the Internet.

It's rare, but these situations do happen. I personally witnessed a situation where a second shooter walked directly to the studio of the established shooter after they'd had a parting of ways, marched into the storage area, and seized a handful of negatives from an important celebrity event. The intruding photographer wanted to take those

images and publicize them in his own advertising materials.

The established photographer sought my advice. I asked him questions I knew any intellectual property attorney would ask. "Were you able to clearly tell who shot which image?" The answer was "no." From that point on, it became apparent that the second shooter could literally seize every single image from the event, simply because it would be a "he said, she said" argument. Without proper identification of the photos, it was impossible for either photographer to prove who shot what.

My unwelcome advice for the established photographer was that I didn't believe there was really anything he could do.

This is why, whenever I was training second shooters or had associate shooters work alongside me at an event, I would clearly mark which images were mine by putting a letter on each of the CompactFlash cards I used. Then I'd have the second shooter sign a sheet when receiving the cards and when returning the cards to me (see the Preflight Checklist, earlier). That way, when I downloaded all of the images from the cards, I could easily distinguish whose images were whose.

We also had a hard rule that no photographer could pick up another photographer's camera at any time to take an image. If the second shooter picked up my camera and took a single shot, then that photographer would be dismissed immediately unless they signed a release stating that all of the images on all of the cards were shot by me.

By taking these steps, it was always very easy to delineate my work from the associate photographer's work. It's

not enough to say to a judge, "Anybody could clearly see that my pictures are superior to his, and therefore, that shot must be mine!" That is subjective and non-conclusive.

What is conclusive, however, is having the second shooter sign a document stating that they received a particular flash card, and then sign the same document again later, stating that all of the images on that card are theirs and none of the others are. Then, should a disagreement come up later (and this happens all the time with second shooters, no matter how much you love them), you can simply say, "Okay fine, here are the images you shot—but under the terms of our second shooter agreement, you cannot use the images of my clients for any of your self-promotion or advertising." That way, the second shooter cannot demand that you relinquish all of your images from an event.

This is such an important topic that I can't believe it's not addressed more often in discussion boards, etc. I think it's because there's a prevailing, unquestioned belief that the studio owns the images when they hire a second shooter. The exact opposite is true.

Another reason to carefully track your CompactFlash cards is in case you have a mechanical problem with one of your cameras. At the beginning of the event you should log not only which photographer shot on which card, but which camera has which card in it. By doing this, you'll know for sure which camera had the problem.

To repeat: your second shooter's images must be clearly identifiable and treated as a different set from your own. Taking this one step alone could save you a tremendous

amount of hassle and could possibly even save your entire business.

How Best To Handle The Second Shooter's Images

There really is only one fair and legal way to handle the images of a second shooter, and that is by having the studio photographer purchase the rights to use each image that will be part of the studio's revenue and ing. Otherwise, the studio will be making money from an artistic creation it doesn't own. Legally, I believe that would constitute theft.

Before I go any further on this topic, I need to clearly state that I am not an intellectual properties attorney, and so I am not a legal expert. However, I have learned few things over the years through the counsel of my law firm, Christie, Parker and Hale (cph.com).

One important point is this. There is a commonly mis-used phrase in discussions about persistent photographers at events. That phrase is "work for hire." What many people do not realize is that the term does not apply to a photographer who shoots second camera images. An example of a work for hire (WFH) might be the commissioning of a sculptor to create a work of art, or a lyricist to write a song. Those are true works for hire. The scope of the work is defined and specific.

But a yet-to-be-photographed image is a completely unknown entity. And this is exactly why having a second shooter sign a WFH agreement before the images are even taken is a pretty useless exercise.

Here's a very silly but instructional example. Let's say

the second shooter signed an agreement before the event that they would turn over the rights to any images they took at the event, in exchange for a fee. Then let's say at that same event, a UFO landed and Elvis Presley stepped out of the spaceship, singing Blue Christmas and wearing blue suede shoes. The associate photographer, being mindful of his contract, would be in quite a dilemma — especially if he was the only one with a camera ready to shoot. Undoubtedly, he or she would shoot the image, but then the rights to that image (now worth millions of dollars) would automatically go to the primary photographer.

Now here comes the lawyer. The lawyer could argue that the second shooter had no idea that such a thing would occur during the event, or that there would be an opportunity to take such a great image. Therefore, any agreement made ahead of time would have been based on incomplete information. This is a great argument, in my opinion. I highly doubt that an agreement signed before any images are taken would be enforceable. Why? Because neither party knows exactly what's going happen during the event.

The photos taken during the event might be worthless, in which case the primary shooter shouldn't be required to pay for them. They might be mediocre "learning experience" images. Or they might be spectacular, in which case the principal photographer could (and should) make a deal to license the copyright of the images from the second shooter with a per-image licensing fee based on the worth of each image.

If a licensing arrangement is satisfactory to both parties, the second shooter and the primary photographer could

sign an agreement, defined by an attorney, that clearly spells out which images are going to be licensed and what the exact fees will be. An example of such an agreement of copyright transfer is available at this website:

http://www.inc.com/tools/assignment-of-copyright.html

What I'm saying is this: the second shooter should have his or her images clearly separated from the images of the primary shooter—we've covered this already. Then, depending on how good those images turn out to be, the second shooter should be able to negotiate a fee for the images and sign a licensing agreement with the primary photographer.

Legally that's really the only arrangement that I could think of that would actually work in a hotly contested dispute between two photographers at the same event. It's a great incentive for the second photographer to capture some stunning images. (After all, if the images are poor, the second shooter might not get paid all.) And if the second photographer gets some really amazing images, then part of the negotiation should be that she can retain the rights to use the images in advertising, or in display samples, or in a brochure. Both parties can then decide what is permissible within those parameters.

Typically the primary photographer would not allow the secondary photographer to advertise the image on the Internet or another mass media outlet because of privacy issues between the contracted photographer and the client. But, armed with the leverage of the incredible image, the second photographer could certainly negotiate to use the image for his own samples.

103

The situation between shooters can potentially get complicated. Think about all the different angles here. Say you're a second shooter, and the primary photographer takes your incredible once-in-a-lifetime image and splashes it all over his website, taking credit as if it was his own. How would you feel?

Or, say you are the studio owner who has had an associate second-shoot with you for years. Imagine the nightmare scenario if this person gets in a fight with you and demands that you release all of the images he or she ever shot with you, and further demands that you not use any of those images for any purpose whatsoever. Now imagine that this person has shot, say, twenty weddings with you over the years. With an easy-to-obtain court order, this person can demand that you not release, without their permission, any image that they possibly could have shot. So now for you to sell those images to your own client, you'll have to get written permission from the second photographer. Who now hates you. This could literally put you out of business.

Second shooting can open up a tremendous can of worms. Again, the two most critical factors are (1) make sure both parties agree in writing as to who took which images, and (2) arrange for the user license of the images to be done on a per-image basis, only after the images are reviewed.

I've also seen photographers sign agreements with their associate shooters called "non-compete" agreements. These essentially stipulate that the second shooter is not allowed to open up a business within a certain geographic proximity, or within a certain number of years after work-

ing with the primary photographer. This concession is granted in exchange for the on-the-job training that comes with being an associate photographer.

Warning, though. In most of jurisdictions I know of, the courts are very reluctant to allow one person to limit another person's income. And one thing that would severely limit a person's income would be to prevent that person from using their job skills. So be careful. If, as a primary shooter, you attempt to use a non-compete agreement against your second shooter, it could come back to bite you. Armed with a good lawyer, that second shooter could shut your business down by seizing control of all of the images taken at any event. So I guess what I'm saying is don't be a jerk.

I don't know if I've opened a hornet's nest by alerting you that a second shooter can cause great stress to your business. But it has to be said. After all, this wonderful profession has some really high highs, but it some pretty low lows, too. And I want to make sure that you're at least aware of what you're getting into each step of the way.

Now that you've read this far, you've earned your stripes. It's time for me to give you some of my best advice about the most important aspect of your business: acquiring clients and making money. I had to experiment for years to learn these lucrative lessons. And now I'm passing them on to you.

Getting Clients:
Starting From Absolute Scratch

I remember when I started thinking about going into business for myself, I was scared to death that I wouldn't get enough work. I mean, how was I going to find 52 clients a year to hire me to shoot their weddings, one per weekend? I was a complete unknown!

To make it worse, though I was 24, I looked like I was 17. (I didn't shave until I was 30.) And I lived with my mom and dad in a two-bedroom apartment. I slept under my desk because it was either have a bed in my bedroom or an office to meet clients! I opted for the latter. I made some business cards and ran my price lists through a duplicator on parchment paper. All I owned was one camera, one display album, and $254.

I can remember, like it was yesterday, that feeling of panic that my phone wouldn't ring. Back then, we had call-in voicemail services where you would dial in your "work" number, punch in your code, and a voice would tell you how many messages you had. Mine always said, "You have no new messages."

These panicky days are well documented in my memoir, *The Accidental Millionaire: How to Succeed in Life Without Really Trying*, which you can find at your local bookstore or on Amazon.com, Kindle, or iBooks. One moment that stands out for me was plunging into a swimming pool, physically nauseated, because I was literally sick of sitting at my desk dialing that voicemail number and hearing that I had no messages. While drifting in the pool, I actually considered making one of those sandwich-board signs that you wear, with the words, "Wed-

ding Photography" and my phone number. I was desperate enough to consider standing on a street corner, waving at cars.

Then I got two pieces of incredible advice that have powered me through a number of very successful businesses. One of them was this:

"Nobody needs a salesman knocking at their door, but everybody would welcome a new friend."

This was advice from my wonderful mentor, Rocky Gunn. He would offer these little Yoda-like tidbits of Zen wisdom whenever I'd ask real world questions like, "How will I find my first customers?" But this one really stuck with me. What he meant was, don't go around bugging everybody for business, just get out there socially and meet people in the industry. They may end up referring you, but you shouldn't have referrals as a goal. Simply see if you can meet people and show them your work, with a focus on making a new friend, not a sale.

And you know what? It really worked! All of my first wedding referrals were from hotel catering representatives and bakeries. (Hanson Cakes in Los Angeles was a tremendous help to me in the very beginning.)

The cake bakery was an awesome place to drum up fast business, because, man, if a person didn't already have a photographer by the time they ordered the cake, then photography was probably not very high on their urgency list. The cake was usually one of the last things they arranged, so if they did still need a photographer by that time, they probably needed one fast.

I would just phone the bakers and caterers and say, "Hi, I'm Gary and I'm new in town and I'd love to swing by, show you my samples, and meet you in person." Then I'd always volunteer to shoot advertising images for them for free.

For one bakery, I shot a huge enlargement of one of their cakes at sunset with models on it dressed as a bride and groom. They blew up one of these enlargements (which I provided for free) and put my business cards below it. This was really nice of them, but what was even more awesome was that they would personally refer me. They'd ask customers if they had a photographer yet, and if not, they'd hand them my card.

This is something you do for a friend. Not something you do for a pushy salesperson.

I'm a terrible salesperson in the conventional sense. I don't have a "tickle" file or a program that tells me when to contact people to bug them. But what makes me terrific at sales is that I only stand behind products I love—which makes it super easy to enthuse about them— and I just present. I don't try to close the deal.

I'm patient, too. You have to be or else you'll go freaking nutso.

The more relaxed you are, and the fewer expectations you have, the more your energy will be aligned to receive abundance rather than repel it. I'll talk about what I call the Law of Repulsion a bit later. In a nutshell, it means the more relaxed you are about getting business, the less you'll repel potential clients or referral sources.

By contrast, I know a photographer who would end his inquiry meetings with the statement: "Well, at this point I'll leave this contract on the table, so you two can discuss things in private. I'll just step out for a minute and then I'll return..." Yuck. This guy did get work, occasionally, but mostly he worked as a second shooter for other photographers. Why? Because his calendar was usually empty.

The other key piece of advice that changed my business life was this:

If you can get someone to use/refer you twice, the odds of their referring you a third time go up 800%.

I read this in a book called Marketing Without Advertising at the beginning of my career. It is one of only four business how-to books I've ever read. I've read Trump's book on real estate, Kiyosaki's Rich Dad, Poor Dad, and a book by a super salesman named Tom Hopkins. None of these held any valuable lessons for me, but Marketing Without Advertising gave me all I ever needed to know.

It describes the success of businesses like Tommy Bahamas, TGI Fridays, among others, who have never advertised. It explains how advertising is a waste of money, because all it does is raise people's defenses. Why? Because in general, people don't like to be "sold to" and are skeptical of claims made in ads. This is especially true in a down economy.

I know of two photographers who purchased full-page ads in a famous bridal magazine. The cost was $20,000 for the space, and one of the photographers actually put a second mortgage on her house to pay for it! The other one I

know personally, so I asked her how the ad had performed for her. She got a total of three inquiries from it.

I've seen the same thing myself. One of my products was on the TODAY Show with Kathie Lee Gifford and Hoda Kotbe. The show had a Nielsen viewership of 2.7 million and it featured one of our FlipCages™—a $19 item that protects point-and-shoot cameras and also functions as a built-in tripod. The segment was "Brilliant Inventions for Summer Fun," or something like that. Do you know how many units we sold as a result of being on National TV, with my website address plastered on the screen for a full nine seconds?

Eight. We grossed $160 as a result of that appearance, which would have cost us about $20,000 for a minute of airtime. Thank goodness we didn't buy a TV ad!

You'd be lucky to see one of the handful of ads we've ever done for the Lightsphere—they're only out there to satisfy the ad budgets of our distributors and ers. For the first five years, I never once ran an ad for the Lightsphere; it sold only by word-of-mouth ral. Though we've sold over 500,000 units to date, this feat was accomplished almost exclusively by referrals from satisfied customers—who, if they buy from us twice or refer us twice, have an 800% chance of doing so a third time!

Marketing Without Advertising explains the concept of the "rave" referral. You probably have a favorite business that you're crazy about, right? It might be Starbucks. It might be a local sushi bar. How many friends have you "raved" to about this business? More than three? See, after the first two, it becomes a habit.

And in a down economy, people really seek referrals from people they trust, typically friends and family members. Advertising increases skepticism, whereas referrals increase trust. Tailoring your business to generate "rave" referrals will plant seeds for a continuous harvest that just grows and grows.

My wedding business was like that. I knew that if I could get a couple to refer two other couples, their likelihood of doing so a third time would go up 800%. And I knew that to get them to do that would require a lot of personal service. So that's where I concentrated most of my attention.

Building a Clientele That's "Pre-filtered For Price"

Many authors and lecturers claim to have the secret to "how to book the high-end bride." It's no secret, really. The fastest way to get there is to have a really high-end wedding planner fall in love with you and refer you.

But that's an elusive target to aim for in the ning. A better way to build a young business is one happy brick at a time.

My prices did eventually become among the highest in the industry by the time I hit my twentieth year in business. My shooting fee, which started at $150, became $4,250 over the course of the years. My mandatory credit card deposit for albums, which started at $250, became $8,250, for a total up-front commitment of $12,500, with final orders that doubled that amount on average. It took a while to get there—years!

But here's what happened. I knew that if a client had a $2,500 order from me, the friends they referred would all know the price they paid was $2,500. And if people are expecting to pay $2,500, they're okay with paying, say, $3,200. (Happy people go over their budget!) Now, assume the $3,200-paying client refers two friends. They'll know that the expenditure was $3,200, and so they might be comfortable spending $3,800… And so on.

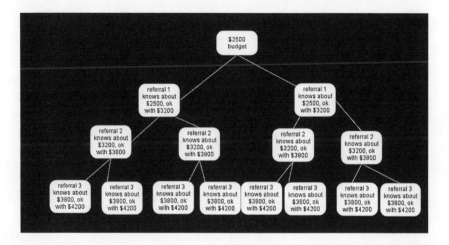

If you can get TWO (not one) referrals from each job, then not only do you build a pyramid, but you build one that's pre-filtered for price. By that I mean, you don't have to explain or justify your price to these clients. They already know what to expect, cost-wise and are ready to book.

If you can make this happen, your business becomes completely free of the grind of explaining your pricing.

Compare this approach to the typical starting photographer who buys a booth at a bridal show. Sure, you'll get a lot of leads this way, but these people have no emotional connection with you, no foundation of trust. Plus, you're in a circus full of other competitors, so price becomes the only real lever handle. Everybody offers "trade-show specials" and so every interaction with potential clients is just an awkward haggling session.

Building a pyramid is the most important lesson I could ever give you. Just picture the tree above when you are dealing with each client.

Don't Be a Diva

Lately, the "Diva" marketing approach has become quite popular among photographers, thanks in part to the book, The 4-Hour Work Week, which has a huge following in the photography blogosphere world. The basic gist of the Diva concept is to make yourself distant and unavailable to clients so you appear to be busy and in-demand. Advocates of this method advise taking your time returning calls or e-mails, even to the point of not returning them at all. Supposedly, this will garner you high-paying clients.

Yeah, right. I completely disagree. This approach basically promotes the idea that being an a**hole is totally hip and cool. One of the Photography workshop gurus openly propagated this message among his Twitter followers and I have never seen such an outburst of anger—to the point where entire websites were dedicated to exposing what a prick this guy is. This guy has problems other than his diva attitude, but having that kind of attitude doesn't help anyone.

As for me, you've probably seen my products wherever professional photographers are gathered. I'm CEO of several "real" companies, with a real factory and a real distribution center, and three vice presidents.

But that doesn't mean I'm too important to write directly to customers who purchase products from my e-store (at garyfong.com) or to give them my direct e-mail address. Of course, this is not something I can provide when a customer purchases my products from a retailer, because, in that case, returns and customer service are the domain of the merchant. But if it comes out of my store,

then I am happy to be contacted directly. And I spend a lot of time on the phone with customers. This type of personal customer service is what really helps drive referrals.

One day I was sitting in the office of the General Manager of the Marina Del Rey Marriott. We were friends because, well, "nobody needs another salesman." And I had done a number of freebie shoots for the hotel to thank them, in a way, for future business.

The phone rang in the GM's office, and he said, "You're kidding. Okay, I'll be right down!" He threw on his suit jacket and said, "I gotta go! Bill Marriott is here and he's down in the kitchen cutting vegetables."

The next thing you know, the GM and the Reservations Manager were also cutting vegetables. It seems that when Bill Marriott had arrived at the property a half-hour earlier, he'd asked the lobby staff if there were any issues at the property. He was told that one of the prep chefs had called in sick. So Mr. Marriott went into the kitchen to cut veggies, explaining that he used to run a restaurant, so he knew how to do this.

That moment changed me forever, and I've told this story to probably a hundred thousand people over the years, in lectures or in books. And this happened over 25 years ago. So while it probably only took Bill Marriott an hour of what sounds like nobility pulling weeds, it had a tremendous effect on the staff, as well as on an outside vendor like myself. And now, maybe, on you!

Currently the world seems to be all about SEO (search engine optimization) and how to get the most followers on Facebook or Twitter. And while I use all of these social

media outlets, (as do my team members on the behalf of my company), there's a difference in what we do. It's called Loyalty Marketing.

Loyalty vs. Awareness Marketing

Loyalty marketing can best be explained as encouraging the use of social media as an outlet for your customers to "rave" about you. If my company, for example, does an outstanding job of customer service, or quickly answers somebody's technical issue or solves a lighting problem, there is a chance our thrilled client will tweet or post a status on their Facebook page saying that we are great. That's Loyalty Marketing.

Awareness marketing, on the other hand, is what we see a lot on Twitter. "Please subscribe to our Twitter feed to be informed of our product giveaways." Or, "Only two seats remain for our upcoming Rockstar Behind the Lens workshop—register now." Awareness marketing just means, essentially, getting in people's faces.

Another example of Awareness Marketing is putting flyers on people's windshields in a parking lot.

Awareness marketing is the ultimate "salesman knocking at your door" that my friend and mentor, Rocky, warned against. No one likes it.

Would you go knocking door to door to offer your photography services? No. Door knocking is a ridiculously inefficient and ineffective technique, and is the ultimate example of "awareness marketing."

Awareness marketing is fundamentally flawed because it is all about the agenda of the marketer. It has nothing to do with the customer or his/her genuine needs. There is something fundamentally repellent about this approach. No one likes to be "assaulted" by quota-driven salesmen

or sales messages. For example, there is a certain retail chain of electronic stores—I think you know the one I'm talking about—whose salespeople "attack" you the literal second you walk in the door. You know they must be working on commission because they are so damned eager to sell to you.

This type of sales strategy has all the appeal of a panhandler charging toward your car at a red light. Why is that we have allowed ourselves to be hypnotized into thinking that using sales techniques we hate to have used on us is the most effective way to sell to others?

Loyalty marketing, on the other hand, is based on a customer's genuine and honest response to a quality experience that you have provided. Focus on that—the customer service experience— at all times, and you won't have to worry about artificially generating tweets and "likes." And you won't have to spend twenty grand on a magazine ad that generates three inquiries.

Yes, it's okay to intelligently work the social media to help encourage happy customers to speak out. But the vast majority of your focus should be on providing the kind of experience they want to speak out about.

Using Jesus in Marketing

Nowadays my mentor's advice about salesmen might be expanded to:

> *Nobody wants a salesman — or a religious recruiter — knocking at their door, but everybody would welcome a new friend.*

Religion has become tied to professional photography marketing in a way that is truly curious. We've all seen God used as a centerpiece of branding. (Think, for example, about ChristianMingle.com, a dating website that has the sheer gonads to use as its tagline, "Find God's Match for You." Wow, so these guys are God's licensed agents on planet Earth! Awesome.) My wife knew someone who gave her website the name Jesus (followed by her name).

But is this really a good idea? Does a majority of the public open its doors to Jehovah's Witnesses carrying printed booklets?

That's why I can't understand why so many tweets or blogs push their religious beliefs on potential customers. It's grown steadily worse as the connection between social media and professional photography has fused.

This type of marketing has taken a credibility hit lately, though.

An Arkansas photographer whose online profile professed an "irrational love for Jesus," Meagan Kunert got thoroughly smacked down by an Internet story about her activities that went viral.

For those of you who haven't heard the story, here is a Twitter account that sums it up rather succinctly:

> *#MeaganKunert took images frm other photogs &*
> *used them as samples of her work-making up*
> *names and stories abt clients. Got caught.*

For more on this, Google "Meagan Kunert Apology Second Chance," and you can read her account of the story,

which has become so famous, I heard this phrase when a photographer found out his images were appearing on someone else's website: "OMG Did you get Meagan Kunert'd?"

It devastated her family financially, and the impact it will likely have on her future will be tremendous.

Some of her biggest critics were Christians. They really pounded her for heralding the name of Christ, yet acting hypocritically. This put a bit of a taint on using Jesus in marketing. For a few minutes, anyway.

How did the whole Jesus thing creep into professional photography? I think part of it stems from a yearning for community that runs deep in the photography business. Maybe it's because photography is such a solitary profession. Hours of editing images can make you yearn for a congregation. We all long to bond with others that share our trade. Our values too.

Look at me—I haven't shot a wedding professionally in nearly a decade, yet still most of my Facebook and Twitter followers are wedding photographers. I realize I create products that are widely used by photographers, but it would be nice to have a few friend requests from guitarists or parents of twins. After pondering this issue for quite a while, I think I understand what's going on.

When you tweet, your words are visible to whatever number of followers you have. Say you have 500, and you tweet something especially funny or poignant. If lots of your followers retweet you, then all of their followers get to read your message. If you consistently broadcast tweets that are "awesome," that number grows exponen-

tially. For example, your 500 could turn to 2500, and then to 1.25 million if everybody retweeted what you said for two generations of retweets.

I don't know if anybody has done a study of this, but I would love to chart what type of Tweets gets the most re-tweets. If I were to guess, I'd say it comes down to a few key factors. One of these would be how often the person tweets (awareness and visibility). But also, tweets that mention scripture, or Jesus, or have words such as "blessed" in them get retweeted much more than others. For some reason, people like to spread messages with Christian references. I have observed this for a while now; it reminds me of an evangelical church. Anything the preacher says is greeted by choruses of "Amen!" or "Praise Jesus."

Water seeks its own level. Wherever there is a hole, or a need, it gets filled with whatever's available. And there seems to be a great demand out there for inspirational messaging. As off-putting as it may be to some, mention-ing Jesus in a tweet or a Facebook status is equally attrac-tive to others, which results in a large number of follow-ers. It's like multilevel marketing.

But it's a risky stance to take, and here's why. While you may attract followers of like beliefs, these are typically other photographers looking for a sense of community. These people are your competition, not your potential cli-ents.

Numbers-wise, most of your potential clients won't share your beliefs. It's the law of averages. You risk al-ienating a majority of potential future clients by advertis-ing your religious beliefs in a prominent way.

Can you imagine what would happen if I put a Christian Fish on each of my product boxes? Sales would plummet because declaring one's religious affiliation is polarizing. It's like being an avid Red Sox fan when you're trying to market to Yankees fans.

So I guess what I'm saying is that it's great to respect all religious beliefs, but you might want to think twice about using God in your marketing. Not only is it iffy from a karmic point of view, but it might just blow up in your face.

How To Set Prices
Discussion

The way I ended my photography career was to raise my wedding price to $120,000. The phone instantly stopped ringing, as I knew it would. Throughout the Internet discussion forums I was described as "the most expensive wedding photographer in the world." This carried with it a certain weird cachet but here's the thing: it did not carry with it any new business.

Do not listen to "consultants" who tell you to arbitrarily raise your price. For instance, I was contacted by one aspiring photographer who had paid $600 for an hour of consultation with who is, in my opinion, extremely irresponsible. He brands himself as not only a marketing expert but also a food product! This consultant doesn't claim a track record of success in photography, (that's a good thing) but his message is nothing more than, "I was able to buy these expensive sunglasses because of my luxury brand (ed note: which is based on eating food). You should be a luxury brand, too, or people won't take you seriously."

Let me try that on for size: Gary "Lasagna" Fong. Nope. Can't do it.

For $600, the "consultant" advised this poor photographer to triple her prices so as to increase her "status" and "prestige." Of course, she listened to the guy, thinking he was an expert, and of course her phone stopped ringing.

This ridiculous advice at $600 per hour on pricing had just made somebody's life miserable and unworkable. Is this honorable?

I hate to be the one to break the news, but if you want to fill your client schedule, especially as a newbie, you have to offer low prices. I know this sounds ridiculously self-evident, but today's workshop gurus all seem to preach the opposite; that the way to Rockstar wealth is by charging high fees. I'm one who absolutely knows that that is a silly proposition. Common sense says that the lower the prices, the more people will choose you.

When I started my wedding photography business, my parents gave me one year of free room and board in their two-bedroom apartment, on one condition: I had to make more money than a medical doctor in my first year of business. If I weren't able to do that, I would have to go to medical school.

At the time doctors earned roughly $100,000 annually, so I had to earn $100,000 in my first year, straight out of the University, with only one camera and a bedroom for an office.

Sound impossible? Well, I'm not a doctor now, am I? If we can put a man on the moon with computers less so-phisticated than an iPod, we can do pretty much anything. The fear of going to medical school is powerful enough to propel me to the moon without any computers.

In sheer panic, I tried to fill my calendar with as many weddings as possible. I estimated that I would need to do one hundred weddings at a thousand dollars apiece in or-der to meet my goal.

Since the average package price at the time was about five hundred dollars, including twenty eight-by-tens in an

album, my goal was quite a stretch. I had no choice but to try to double the industry average in my first year.

Working out of my bedroom office was a real treat, let me tell you. My mom grew up in Korea, so we always had this smelly Kim chi odor permeating our little apartment. Plus, she always fried fish. I can't believe I booked a single wedding with that type of presentation.

I had one desk, some enlargements on the wall, an old Keyport computer, and the rollaway pad for me to slide under my desk so I could sleep there at night. Oh and a little "MasterCard/Visa Welcome Here" sticker on my bedroom/office door.

One day as I was meeting with an attorney couple that were having their wedding at the prestigious Riviera Country Club in Los Angeles, I felt as if I was close to getting hired until my mom shuffled in, half-asleep, with a plate of cookies and two glasses of milk for my "friends." Obviously I didn't get that booking.

But I managed to book forty-nine weddings that first year, asking only $150 for (I kid you not) "no time limit, and no minimum print order." I did require that clients give me a refundable $250 credit card deposit for album design, bringing the total pre-wedding commitment to $400. This was still below the typical $500 package, which included twenty, eight-by-tens, but what was different about me was that my price really was $150. If they didn't like my images, they would get their $250 deposit back in total or in part, and they weren't required to buy anything. That was in my contract. I made the "barrier to entry" really low.

I earned \$64,190 that year—short of my goal, but this was 1984. Adjusted for inflation it was a ton of money. So my folks congratulated me (eventually) and conceded that I could continue with wedding photography.

I've never had to refund any of my album design deposits. And in that first year, despite a low, low \$150 shooting fee, and despite the fact that I was only able to book last-minute weddings, I still made more than the vast majority of experienced wedding shooters made, then or now.

Therefore, I was able to sell a lot of images to people who didn't feel like they needed a professional photographer. In fact, I sold wedding albums that were so fat, the album company put me on a national speaking tour after only two years in the business. They wanted me to teach others how I was able to sell such large photo collections after such a short amount of time as a wedding photographer.

Though my work wasn't great, my pricing and merchandising approach was second to none. It was the strategy I used in my first year in business and it never changed in the twenty years I stayed in the trade.

It all revolved around the concept of serving not only as a photographer, but also as a consultant/designer of beautiful, personalized wedding albums. That's what distinguished me from anybody else at the time, and that's what allowed me to build a clientele that didn't haggle with me about prices.

I made it really easy and cheap for them to hire me. Then I relied on my ability to sell prints to make my real

income.

Offering a ridiculously low shooting fee and a low pre-wedding financial commitment was a great way to fill up my calendar quickly. I was kind of like Groupon before there was an Internet. The only problem with Groupon vendors is that they lose their shirts on each transaction. I had to make sure I not only got as many customers as I could, but also made a lot of revenue with each one.

And I did. It was kind of like alchemy. I turned the very low-end bride into a higher end bride, strictly through merchandising. The key insight that enabled me to do so was this: wonderful images from the bride's own wedding are a much better sales tool than fancy display albums filled with other people's photos. And you can't show them their own images before the event, now can you?

What worked for me was selling one image at a time, after the wedding. I think that it would be an easily adopted and profitable practice today, as it just seems so simple and logical.

Maximizing Revenue

In order to maximize your profitability, you have to achieve two things at the same time: first you have to fill your appointment book with paying clients. That's not going to happen when you charge a high fee before the event. Second, you have to maximize the revenue for each low-cost booking.

This may seem like a paradox but it's not. The way you do it is by earning a majority of the revenue from your clients after the event, after they've seen the photos. This means that you have to do a really great job shooting the event so that they can't resist buying lots of your images. They just have to own them.

Conversely, when you include a fully edited DVD as a standard part of your package price, what's your incentive to bust your ass to get the best shots? You can do a great job or a mediocre job and you get paid the same amount.

Me, I worked a wedding like crazy, looking for great images in every corner and at every moment. I always stayed until the very end, adding to my inventory of salable images, knowing that if I could sell an extra twenty shots from that final hour of laughter and tearful goodbyes, I'd add $300 to the purchase.

But album design was the real secret to my success. After the wedding, I would always sit down and design a proposed album layout to show the couple before I let them see all of the images. So they'd see this really cool "storybook" framework first, and fall in love with it. Then I'd start showing them images.

In order for you to understand the little miracle I creat-

ed called Storybook Weddings Photography, I'll have to explain it in a little more detail.

Again, when I started shooting weddings, I set up my price structure so that I was essentially shooting "on spec." "Hire me," went my pitch. "Your only risk is $150, which is $350 below the rest of the competition. Let me show you what I can do for you, and then you can buy only the images you want."

Everyone loved this fee structure. It was a total win/win. But, of course, I couldn't survive on such a low fee. So once I had them booked, I had to figure out how to merchandise individual images so that I would sell lots and lots of them.

You might be thinking to yourself, "Why does Gary Fong suggest low unit pricing when all of the other gurus say to aim for the high-end client?" My answer is this: Because it's realistic and also amazingly profitable. Because it lets you turn lower-end clients into higher-end clients.

Look at it this way. Say you do a pretty typical package where you shoot a whole event including the high resolution DVD for $500. If you include 2,000 images on the DVD (which many do—and this is edited AND retouched!), it works out to a quarter an image! That's your pay.

Why not show them the images for review, and then sell them each "polished" image for $5? Here's what will happen, and I've seen it a zillion times. They'll say, "Aw, what's five dollars? I'll skip Starbucks." And they'll wind up with a huge purchase, one beautiful image at a time.

In my first year (1984), I shot 49 weddings at a $1,390 average, for earnings of $64,190 ($150 for the shoot, $6 for a small print, and $12 for an 8 x 10). By year two, I shot 63 weddings for $121,900. Year three it was 69 weddings for $171,500. At the peak, I was shooting 42 weddings and earning just shy of $750,000 a year, and had a large (2,200 sq. ft.) studio with a five-line phone system and three full-time employees.

I never aimed for the high-end bride or the celebrity gig, but those came my way on their own.

So consider charging an affordable basic fee to do the shoot, and a small price per polished image. Then work to create a marketing environment that makes your clients want to splurge.

As a starting suggestion, rather than charging $500 for a shoot-to-burn fee, why not charge $350 for your time, and then $5 per polished high-resolution image ("polished" meaning light retouching and exposure/contrast adjustment)? I guarantee that, unless you're a terrible photographer, you'll make more money per job this way. And your customers will be totally delighted spending more money with you. Why? Because they voluntarily choose each image they decide to buy. It's a positive energy exchange, all the way around. And no one's going to criticize your work, because if they don't like an image, they don't have to buy it. You don't have to get into those dreaded arguments about what's "good" and what's "bad."

After you've worked this way for a while and your calendar begins steadily filling up, you can gently raise your

prices once a year.

Often I see photographers charging a small fee to shoot the event, and then spending hours and hours ing. When I ask why, the answer is usually, "Because I shoot in RAW, and the exposures are all over the place, so I need to correct them before I make JPGs."

This work normally takes a photographer about two weeks to do. Does the idea of doing all of that labor for a few hundred dollars sound super enticing to you as a business plan?

Package Pricing vs. a La Carte Pricing

I'd estimate that 95% of photographers establish their first price list with a set of packages: Small / Medium/ Large/ Deluxe. They may use fancier names than that, of course. (I've actually heard of one photographer who called his packages "Short, Tall, Venti, and Grande. Oy.) The problem with selling predefined packages before the wedding is that the dollar number for your package goes into the overall budget number for the wedding. You're then competing with the caterer, the DJ, the print shop, the florist, the tux shop, and a host of others for a small pie-wedge of a very limited and over-stressed budget.

So if a couple has a total of $10,000 to spend on their wedding, a $3,500 photographer is probably way out of the question. But people with a small up-front budget for photography can turn out to be very profitable customers, despite their small budget. The secret is to move most of your payment out of their up-front wedding budget and collect it after the wedding (when they've recovered from the financial hit a bit and may even have a few grand in gift money to blow).

The problem with package pricing—and it's a huge one—is the preconceived budget and print count. No matter how good a job you do at the shoot, the client will whittle down their selection of images to fit the package they paid for, simply because you've done such a master-ful job of ramming a pre-set number into their mind. This is crazy, because it artificially puts a cap on your sales.

So studios that offer twenty eight-by-tens for $495 will doggedly deliver twenty eight-by-tens at the finish. Even if the photographer took 300 incredible images, the client

will reject 280 of them, simply to arrive at the pre-sold quantity.

My approach was much more open-ended.

And let me tell you this. No bride wants to walk away from a great shot from her wedding day. If she likes the shot, she will want to own it and she will find a way to pay for it. And she'll do so quite happily because she knows what's she's getting, not guessing at a purchase price based on images she hasn't yet seen.

Maneuvering Past the Budget Obstacle

One of my photographer friends explained to me her theory on her recent drop in bookings. "These days, couples have such a small budget to work with that they just wind up finding photographers on Craigslist."

This makes a ton of sense. On the surface. That's the dilemma: everybody has a small budget. But who doesn't want great photographs? Great photographers, of course, have a high package fee, so clients end up going with the cheaper beginners, who do a better job on their pre-fabricated websites and blog templates than they do on their wedding photos.

In the previous section I explained that perhaps the reason clients don't book you is because your package price is too high, and they can't find a way to fit you into their budget. So, again, you need to make your up-front costs as low as possible and make your money on the back end.

"But wait," you might argue, "how can I make anything on the back end? These days' clients want all the

high-res digital files on DVD as part of the pre-paid package. That's what my competition is offering." My question is this, why not offer the DVD, but only upon delivery of the finished album?

Clients could be willing to forego this option if your up-front prices are appealing and your quality is good. And you can always frame your "no-DVD-until-delivery-of-album" policy as a quality control issue. Put it in your contract that in order to ensure your reputation for quality, the initial album must be produced by you before any digital images will be released to the client. Then focus your business attention on being both the best photographer and the best album designer you can be.

In my business I never gave out negatives or digital image files. I understand that there is a lot of peer-pressure to do this nowadays, but your sales average can't grow year to year, because it's really hard to offer DVD's at multiples of the cost of your competitors. Most importantly, you can't control the quality of your raw images, and if they look terrible on the Internet or imprints, there goes your reputation.

I was never solely a wedding photographer. I was a photographer who was also an album artist. You got the whole package when you hired me. My complete service was to create a "Storybook Wedding" album, from start to finish.

I froze my site, as it was the day I retired nine years ago. You can visit it at
http://www.storybookweddings.com.

On it, you'll see how album-centered my approach was.

The Pre-Design Approach

So once the booking was made, the burden of generating income was on me from that point forward. Without a way to entice the client to purchase more images, I would be left with nothing but a small shooting fee and a sprinkling of images that were worthless to anyone but the married couple.

But I consistently got large album orders. How?

I would pre-design the album, and that would be the first thing that they saw after their wedding. In my early days, I would just design the album on scrap paper, folded and stapled to look like a little book. And then, with a pen, I would write in the image numbers where they would fit on the page. The client was given a corresponding set of numbered proofs to examine (but not keep). They would match the image numbers to the layout and visualize these clusters of images on the page.

This was a very crude approach and not visual enough. As technology got better, I started to design my albums in Photoshop. These were still pretty crude—basically the images slapped onto an open spread with no effects, and no retouching. (I later co-created a software product that allowed album designers to easily create sample albums that were much more attractive.)

Using the software templates, I would upload web-optimized images to the Internet for the couple to see. But this is very important: my original, "rough" design for the album, with some pre-selected photos in it, was the only thing the couple would see for two weeks. I wouldn't re-

lease the rest of the images yet, because if I did that, their attention would be on combing through the images, not on the album. In fact, they might get so focused on the images; they'd decide they didn't even need an album.

When you give them two weeks and your album mockup is all they see of their wedding, you shape their conceptual thinking. Before long, they can't picture the album any other way (except for a few substitutions). If you do a really good pre-design, and it's very clever and personalized, with layouts on each page that tell a connected story, you'll find (as I did) that it's extremely difficult for them to take images out of the layout. Because they've fallen in love with the visual story you've told.

The story concept was crucial. All through the album, there'd be these little story sequences—the ceremony sequence, the cake-cutting sequence, the bouquet-tossing sequence. If you put these mini-stories together well, no one wants to remove shots from them. And remember, each shot is a separate sale for you.

After two weeks, as stipulated in the contract, I would then release all of the images for inspection. When they saw all of the images, basically all they'd be looking for was a few new shots to replace certain ones they didn't like in the predesigned layout. They wouldn't be trying to change the layout itself.

I always made my pre-designs huge, and at the start of the album I always printed the phrase, "This is a rough design for positioning only." That disclaimer was extremely important when questions would come up such as, "I get all of this for my pre-design deposit?" No, you don't get the images; those you have to buy separately.

Doing a predesigned layout was no easy task. It would take an eight-hour day. But this isn't a lot of time compared to the hours the typical photographer spends in Lightroom parsing raw images. I always did my predesigns the Monday following the wedding so that the whole story line of the couple's wedding day was still fresh in my mind.

After doing this for a while, I established some popular layouts. I then began shooting with the final page layout in mind. For example, when the bride and her father were about to walk down the aisle and they'd appear in the church doors, I would use a telephoto lens to take an image of the left aisle, with everybody's expression lighting up. Then I would take an image of the right aisle, and pair the two side-by-side.

The minute I started to think about album design while I was actually shooting the event, I became a much better photographic storyteller. And I'd be really excited to go back to my computer and cook up a gorgeous predesigned layout for the couple.

Selling the Images And Collecting Payment

I can't emphasize enough how important it is to get the pre-design in front of the couple within one week after the event. If you wait too long, the thrill of the memories begin to get replaced by real world concerns like the need for a new refrigerator. But also, a wedding day is usually so much fun that the couple wants the dream to continue. Once the honeymoon has ended, you can keep the dream going by taking over as the organized planner for the album design. You make the appointments; you encourage the couple to come in for their design sessions. That way the excitement of the wedding day continues.

So one week after the wedding my clients would have the pre-design to look at for two weeks. After two weeks I would release all of the images so they could make substitutions in their books. I would let them do that for two weeks, scheduling up to three back-and-forth design sessions. If they needed more than three sessions to decide on the final layout, I charged them $350 for each additional session. It is very important to put this in your contract, because if you don't, the indecisive client can become a nightmare.

After three "ricochets" of deletions and substitutions for the finished album, I would count up how many images were in their book, give them a proposed invoice with the à la carte prices, and break the tough news to them that their book was going to cost quite a bit more than they originally planned.

But my ace in the hole was the fact that they were already thrilled with the outcome. Because of that, they would always find some way to pay for it. It also helped

that I collected a design deposit before the wedding day. So, for example, if their book was $1,500 and the design deposit was $500, I would add up everything and tell them that the balance was $1,500. I would then ease the pain by reminding them they had pre-paid $500. This now left them with a $1,000 balance. If they were still stressed out about that, I would then explain (as per the contract) that I needed only half of the remaining balance to begin the work of binding the book, ordering the prints, etc., and the balance would be due in six to eight weeks when the album was finished.

What I essentially did was split their album fee up into three equal monthly payments. I tried to do that for everyone. You could always tell what my average earnings were throughout my career because I always made the deposit amount one third of my average album sale. So in the days when my mandatory deposit was $750, that meant my average album sale was $2,250. When my required deposit was $5,000, which meant my average album sale had gone up to $15,000.

This is what I used to call my magical rule of thirds. I split the album payments into three monthly payments because that way each time they came in to visit me and move one step closer to the finished album, they would get in the habit of bringing a payment for the same amount of money. I don't know why this is so comforting to people, but it is.

The question I am asked most often when talking about the "pre-design" concept is, "What if I do all of this free design work and they don't buy a larger album?" While that is always a possibility, it is very rare. In my experience, it never happened. Even couples who were not picture peo-

ple were converted into picture people when they saw the album concept because this was their story of their most memorable day. If you get a big album order, it's a huge compliment from the client. It says, "I didn't know I was going to be so excited about my photos to go this far over my budget, but your photos were so fantastic that I can't say no.

Pricing – Be Friendly, Yet <u>Totally Inflexible</u>

Whatever pricing method you decide to use, you are eventually going to have to talk prices with you clients. Explaining pricing is the most uncomfortable ordeal for the professional photographer, or any other creative pro. When you aren't hired because your prices are too high, it implies that you're not worth that price. And that, in a nutshell, amounts to personal rejection.

That's why I really liked my pricing methods. I offered affordable shooting fees, but the majority of my revenue came from the sale of products, such as prints and albums, after the wedding. So any rejection or approval was not a reflection of my worth as a photographer. It was a reflection of one particular job I had done.

This pricing structure also turned me into a hard-working, quality-focused photographer. Because I was never paid a firm fee for my shots, I knew I had to bring back great images from the event that people would want to buy voluntarily.

When it came to discussing prices, though, I was always extremely firm. And that's how you need to be. If you show fuzzy boundaries, everybody gets upset. Clients think they're supposed to haggle and many of them resent this. Others will keep bulldozing you until you relent and offer them a better deal.

You have to think of clients as if they're children. If they sense an opening, they'll push your boundaries, and if you're weak, they will take over your world. You have to be consistent and firm—but friendly—if they ask for discounts.

If you do intend to give discounts or specials—or to throw anything extra at all into the deal—put it in your contract at the beginning. Once the deal is signed, then anytime a new request comes up, just point to the contract. If they say, "Hey, can we get an additional high-res disk?" (For example), here's your answer: "Hang on, let me check your contract. Nope, I'm sorry, that isn't included. Would you like to buy one?"

The contract is your friend. Keep pointing to it. All the time. Once clients know that your answer is not going to change, they'll quit asking.

I read this great book called The Gift of Fear. It was written by Gavin DeBecker, a security expert who protects many of Hollywood's biggest stars. So he's an expert on dealing with "pesky" people.

He said that one of his clients was being harassed by an ex-boyfriend who would call at all hours of the day. Hundreds of times. Until finally she would grab the phone and shout, "What the hell do you want?!"

To which Mr. DeBecker remarked, "Congratulations, you have just trained the stalker that it takes 200 calls before you will answer." The client was not firm, and, because of that, the caller continued harassing her.

DeBecker advised her to say the following: "I want to make this very clear, because we will not have this discussion again. I am not attracted to you and I am certain that I never will be." And then hang up. For good.

I thought that was great advice. And highly applicable

to client relations. Be very, very clear about what is possible and what isn't. You see, if they ask you for something extra, and you say, "Well, hmmm, let me think about that," you're hosed. You've just opened a door and now you're going to look like the bad guy if you slam it shut.

Remember the magic phrase I mentioned earlier, "My prices are based on industry standards for photographers of my skill and experience." Print this phrase on your price lists, memorize it, and repeat it often. It's your story and you're sticking to it.

This statement depersonalizes the pricing issue and eliminates the back-and-forth of price negotiation. It's like working at Wal-Mart. You don't see people haggling with the cashier over prices. Why? Because it's very clear that if they tried it, they'd be rebuffed. What if you were at the checkout and you asked the cashier if he could take 25% off your eggs, and he said, "Let me ask my manager"? Then, after a few minutes he came back and said, "The manager said no." You'd be mad at the manager for not giving you your way and you'd be mad at the store too.

That's because the cashier made the mistake of letting you think there was wiggle room. There isn't. Prices are what they are. They're based on decisions made by others and are set by industry trends.

So when a client asks you for a "deal" after the contract is signed, picture yourself as the cashier at Wal-Mart. Your answer is simply no, and no means no. When you utter the phrase, "My prices are based on industry standards for photographers of my skill and experience," you detach yourself from having to justify your rates. People don't feel the need to argue over an industry

standard. (The only problem nowadays is that the "industry standard" is getting lower by the week. Man, I hope this book starts a reverse in that trend.)

So let's review. If you're going to throw in discounts or extras, make sure they are spelled out explicitly in the contract. If the client tries to take an inch and turn it into a foot, point to the contract. Say no, firmly and politely, and use the "industry standard" line.

If they keep bugging you, just be friendly yet inflexible, and say, "I'm sorry, but no." Don't say dumb things like, "I would if I could..." or go into a long explanation of what your equipment cost, how many hours you had to train, yada, yada, yada. The more you say, the more rope you give them to hang you with. Make your language firm and final—but, of course, friendly and ful. Don't be a pr**k and say, "OMG, did you just ask for a deal off my albums? I'm going to tweet this to Jupiter and back with a ROFLMAO." Yeah, don't do that.

Interior Designs:
Ideal Meeting Space For The Face-to Face

Now we're going to talk about what happens when the client shows up at your studio for the initial pitch meeting.

The goal of the pitch meeting is, of course, to book the wedding. You may have all of the skills, creativity, experience, and personal rapport to be the perfect photographer for your client. But the simplest errors in your pitch meeting can cut that opportunity short. Having tried three different studio locations, multiple furniture arrangements, and over 3,000 client pitch meetings, I'll share with you what works best, and why.

A cubbyhole room at the end of a hallway might make a cozy, intimate library or a home office insulated from outside distractions. It might also be a great location for your working or editing area, but it's not a good place to meet clients. I've tried this and it really lowered my success rate at getting hired.

I found the deeper we would venture into the cozy confines of my building, the more tightly the bride would clutch her purse and the more nervously her eyes would dart around. It's an animal thing. People don't like feeling confined, or trapped in someone else's inner sanctum. While the bride-to-be is trying to get comfortable in your cocoon/man-cave/secret lab/hidden kidnap chamber, she probably hasn't heard half of what you've been saying. Caging your potential client in could remind them of many unpleasant things, such as being called to the principal's office, being locked in a cloakroom as a kid, or walking into a marriage counselor's "cozy" treatment room.

I'm only guessing at the reasons why confinement is an issue for many people, and there's no one–size-fits-all ex-

planation; all I'm saying is that I was noticeably less successful when I used an interior meeting space than when I used one out in the open, near the entry area.

High ceilings, (if you have them), having lots of window light and uncluttered furnishings works the best. If your space is small, decorate it minimally so you have as much floor showing as possible. More visible floor means less clutter, and a more spacious feeling.

I was once helping a friend lay out her new office via Skype webcam. I asked her to carry the laptop through the front door, and walk me to where she met with clients. We went through a narrow "gallery" area where prints were hung for public display. Then we took a turn and moved down a hallway into what I thought was going to be a black-and-white darkroom. The door opened, and there it was, the meeting room. There was a wide ottoman butted up against one wall, and a writing desk on the opposite wall. Between these two pieces of furniture sat a sofa table with albums stacked underneath it and some small, framed prints on top. A large, leafy palm softened the corner, and a silk flower arrangement decorated an end table.

After years of experience, I knew why this meeting room would be a disaster. It's claustrophobic. The client has to sit on a low, backless ottoman with her back literally against the wall. There was little wonder why this excellent, talented photographer with more-than-reasonable prices rarely got hired. The meeting space was all-wrong.

Here are a few of the reasons:

- *The client was forced to sit lower than the photographer's office chair height. This makes the client feel talked down to.*

- *Inner sanctum problem (noted above) — the room*

*was dark, artificially lit, claustrophobic, and was lo-
cated one door, two turns, and a hallway away from
the front door. Remember that when you guide a per-
son that far inside your business location, they're go-
ing to spend the first few minutes trying to recall the
exit path. This is a pure instinct of self-preservation.*

- *No table to hide the client's tummies (more on
 this in a bit).*

- *No large bowl of M&M's (plain, not peanut;
 more on this in a moment, too).*

After taking the brief video tour, I offered my sugges-
tions for redesigning the layout. Here's what we did:

Removed the walled-in display area by the front win-
dow in order to open up light to the "great room" meeting
area. If you have a closed-in window display, there's no
reason for clients to come inside and see more. You've put
your best stuff out front, and, well, that's that. Conversely,
a window revealing an airy meeting room/gallery invites
people to come inside and view the work.

Shrank the wall images to 5x7, tastefully framed in huge
20x24 mats. I didn't discover this truth until my third stu-
dio, but when I put huge images on my wall, it gave the
client "implied sticker shock." Subconsciously, it conveyed
the message, "Hi, new person. Come inside. See the wall?
I'll probably pressure you into buying one of these giant-
ass enlargements by the time I'm done with you! Ha!"
Clients want to feel curious to explore your offerings, not
assaulted by your biggest and most expensive options.
When you go to a jeweler, do you see huge, framed wall
images of 15-carat engagement rings covering the walls?
How relaxed would you feel listening to the jeweler's spiel,
surrounded by all of this?

Installed a solid (non-glass), four-person, bar-height table with four barstools as the print-viewing area. Using a dining table for viewing prints is not effective. You'll notice when people are sitting in a dining room chair, they soon begin to shift in a fidgety manner. Placing them at barstool level allows them to support their feet on a bar, lengthening their body profile to a near-standing height, which is refreshing, open, and airy. Sitting in a low chair feels more claustrophobic.

Placed soft but directional LED lighting on wire tracks to provide sparkling illumination, contrast, and saturation to the images and books. If you go to a jewelry store, you'll notice that even your cheap, dirty Timex watch sparkles like a diamond. That's because of the lights. They're set up high and placed at an angle where the product sparkles. While pawnshops might have boxed fluorescent lights set into drop ceilings, you'll never see this in a successful jewelry store.

Maximized Floor Space. The more floors you can see, the less clutter there is. The less clutter there is, the more open the space becomes, and you create an environment that is the opposite of confining.

What To Wear

You, yourself, of course, are a critical aspect of your business.

The most important piece of advice I can give you about presenting yourself is this: when you're sitting in front of your potential clients, they're trying to picture you at their cocktail hour. To put it bluntly, they don't want to be embarrassed by your presence. Therefore, grooming is essential. I know, I know, some photographers can get away with the appearance of being "artistes," but that will hurt your chances of converting the maximum number of potential clients into actual clients.

When you're thinking about what to wear for the client meeting, think cocktail hour. I'm not saying you should look like a cocktail hour guest — they would probably wear a suit or a black dress and heels — I'm saying you should try to look like you could blend in at the party. Typically, wearing all black is a safe bet. Try to picture how you would feel interviewing a photographer who wore a pastel polo shirt and khaki pants, versus one who wore more subdued shades of gray or black.

Ladies should wear slacks because, as a professional photographer, wearing a dress or skirt is not conducive to the constant bending down that is required.

Try not to dress too flashily, or too suggestively (women), as you'll only create discomfort between you and your potential bride if the groom happens to be at the interview.

M&M's

A successful client meeting is determined, to a large extent, by the length of your interview. This doesn't mean you rehearse a two-hour presentation, it means you try to get them to visit with you for so long that they're shocked at how fast time flew because they were enjoying your company.

Confining your client, making them feel closed-off and uncomfortable, cuts the meeting short. And anytime they cut the meeting short, you can assume that they actually wanted to end it much earlier, but were too polite to say so. Which means that whatever you've been saying for the last ten minutes went nowhere.

We're back to claustrophobia again. If they feel eager to leave your place, you can rest assured they won't want to come back. Design your place so they'll want to come back and visit again and again.

This means M&M's in a large bowl (with a hand sanitizer nearby). I've tried Reese's Peanut Butter Cups. Nope. They'll have one, then spend the next few minutes pondering where the hell to put the little gold ball of foil, not hearing a word you say. Same with Hershey's Kisses, only it's a little silver ball with a paper tag sticking out of it. I remember one hungry potential client who chowed through eight Hershey's kisses, then spent most of her time during the interview arranging the little silver balls in a long, neat row. In fact, when she made the line perfectly straight, with the balls spaced apart to perfection (which took a while), I said, "Wow look at that!" And she said, "Yeah, wow — look at that."

We had officially switched our focus to her work, not

mine.

When I brought out the display book to show her, she actually changed seats so she wouldn't disrupt her work of art. What will she remember about our meeting? That she spent an hour, arranging little silver balls, into a nice, neat row?

After Hershey's Kisses, I tried lollipops. Wow, bad idea. Take my word for it.

Finally, I switched to M&M's. I myself favor the peanut ones, so we offered those at first. That didn't last long because I had a client with a peanut allergy who said goodbye before even sitting down (same reason Reese's Pieces won't work). So we switched to plain M&M's.

Here's the thing about M&M's. And it's actually quite miraculous when you think about it. Each is about 20 calories, yet a person can go through over 300 of them in an hour and not realize it. So yes, that's 6,000 calories eaten in a hypnotic trance. One right after the other, every ten seconds.

The mistake I made, at first, was in choosing a small bowl. The client could see the rapidly shrinking supply and would quickly become embarrassed. It didn't take me hearing too many, "Oh my God, I'm such a pig"s or "How am I going to fit in my dress now"s before I realized that I had to either (a) remove the M&M's bowl or (b) get a huge, "bottomless" bowl. I opted for (b).

You see, the M&M's had to stay. Here's why. I noticed that clients were far more attentive, asked more questions, and seemed more connected to me and my studio when they were popping the colorful little buttons into their mouth one after another. There is usually a ten-second du-

151

ration between pops of M&M's (time this yourself), and if it's hard to get up and walk away from a bowl of M&M's, then it's equally hard to walk away from your showing table. It's scientifically impossible to fill up on M&M's, and if you use a big bowl, they won't realize how many they snarfed through. The last thing you want is for them to feel puffy and bloated. (Remember to munch a few M&M's yourself so when you grab the refill bag to replenish, they won't think it was they who ate them all.)

Why the Solid Table? I mentioned a solid table earlier. This is important. Why? The solid table hides your client's tummy. This is not a small factor. It's one of the biggest, most important rules in defining your presentation area. Hide the tummy. Here's the reason:

When a client is meeting with you as a professional photographer, it's intimidating because of all of the beautiful people in your displays! (Photographers tend to not only put their best work on display, but their best-looking clients on display as well.) How often I have heard, "I'm not photogenic like your other clients." People feel as if you are judging their looks because you are in the profession of photographing good-looking people, as evidenced by the samples on your website and in your studio.

And so, if their tummies are visible, they will instinctively suck in their guts. Next time you're hanging around with close friends or family, and watching TV, look at everybody's midsection. Pooched and distended. Not very Vanity Fair. Now imagine how those abs would tighten up if a famous photographer walked into the room.

A solid table hides the belly. This keeps the client from sucking their gut in. Why is this good? Because sucking in the gut restricts breathing. Restricting breathing leads to — yup, you guessed it — claustrophobia. And claustrophobia

can end a meeting early.

Test this yourself. Hold in your gut and try to read the next four pages. See how much of the content you absorb during that time. (And then go back and read it again with your belly pooched because the next four pages are really good!)

Same with the bar-height table. Barstools allow people to be quick off their feat, and quick on their feet. Barstools subconsciously tell the client she won't be stuck here. Later you can lead her to a nice sofa for further conversation and interviews, but not while the work is being presented.

Have you ever had a meeting go south on you, and when the potential client walks out you ask yourself, "What the hell just happened?" Every once in a while (I hope not too often) your meeting will end before you even get to the good stuff.

Needless to say, this used to bug me, so I kept a journal where I would document my thoughts on the meeting, whether the client booked or didn't book, how they behaved, at what point they ran away in terror, that kind of thing. As the years went on and I made continued fine tunings to my presentation, as well as to my presentation space, those abruptly ended meetings became almost nonexistent. So give my above ideas a try. They're the result of a lot of observation, reviewing, and tweaking.

Interview Skills

If you're like most photographers, you have a pretty comprehensive website with lots of samples on display. So when you get together for the initial face-to-face interview, you need to understand that you have already passed the screening process. The client basically likes your work. You have made it to the next stage. So showing a lot more of your work at this point would be redundant. When you get together for your first face-to-face, it's all about the interview.

Once everybody is seated in your ideal presentation space, it's time to have the couple describe to you their wedding day in the greatest detail possible. This includes their preferences, which family members don't get along with which others, the table favors, the centerpieces, the flowers, the cake, the music, how the wedding party will be dressed, how old the flower girl will be. Everything.

Take notes during this appointment, and remember the old rule of thumb: you have two ears and only one mouth. That means: listen more than talk. Ask questions and jot notes. Again, the client has already seen your work on the Internet, so a long photo presentation at this point would be counterproductive.

Take notes as if you've already been hired. Speak in a way that subtly includes you in the wedding-day plans. For example, when she starts talking about where she's going arrive in her limo, put yourself into her visual picture by saying things like, "So what I'll do is hide the groom in the sanctuary until you get into the bride's dressing room, and then once we have the groom hidden, we can start photographing you with your wedding party and family members." See how that works?

Take the kinds of notes you would need to actually do the job. Jot down timing constraints and scheduling ideas. Suggest time frames for photographs. This builds the client's trust that you know what you're doing and will be managing the details on her wedding day. Have a notepad preprinted with a form that looks official and has two boxes on the top, "BRIDE AND GROOM," and "DATE OF EVENT." Make it look like professional notes that you would put in a client file. This is a subtle touch, but it communicates confidence and assurance, without being pushy.

Treat the initial interview like a planning session for the big day.

Follow Up Call? Yes/No?

I'm often asked, "After the initial interview, should I contact potential clients with a follow-up call?" I myself never did it, and it's probably because it's not my style to follow clients all around town asking them if they've made their minds up yet.

Those of my friends who did make a habit of calling people back received an almost universal response, which was, "We really like your work, but we're hesitant about the price." This, of course, opens the door for you to discount your price, which is a great way to cultivate a problem client. We talked about this earlier.

You should never feel like you have to pursue a client. If bookings are slow, then use your "extra" time to design more highly personalized albums for the few clients you do have, and you'll find the revenue you take in that way more than makes up for your low volume.

It also helps to have very low overhead and some good savings in the bank. That way you won't be desperate to

book the event in order to pay your rent. I'll talk about managing cash flow in another chapter but for now my opinion on following up client interviews with a phone call is "not a great idea."

Teaching Clients How to Choose a Photographer

One of the main services you can and should provide for your clients is to help them understand how to successfully hire a photographer, whether it's you or someone else.

This is a huge service to clients, and one it will really appreciate. After all, they don't know the world of photography; you do. It's kind of like how the diamond industry came up with these guides to help men choose a diamond for a girl: the ring should cost three months' salary; the four C's of selecting a diamond are...

In that same spirit, I'm offering you the following questionnaire that you can present to your clients as a guide to how to select a photographer.

TRUTH IN DISCLOSURE DECLARATION: PROFESSIONAL PHOTOGRAPHER

Contact Information

Name(s) [Last, First, Initial]		Website
Mailing Address	Street Province	City/Town Postal Code
Residence Telephone Number () -	Cellular Telephone Number () Business Telephone Number () ext	E-mail Address

Professional Experience

How Many Events Have You Shot Photographically As A Paid, Primary Photographer? How Many Weddings? Events ___ / Weddings ___	Over How Many Years?	Have you ever lost digital images of an event via accidental deletion, loss, or damage of media? YES or NO
Is All Of The Work On Your Website Listed Above Samples From Actual Paid Clients? YES or NO (Not As a 2nd Shooter or 'Staged' shoots with models)	What Resolution Will You Be Capturing Your Files?	How Many Usable Images Per Hour Do You Typically Deliver?
May I See A Complete Selection of Images From Three Recent Weddings From Start To Finish? YES or NO (Please Do Not List Equipment You Plan to Rent Specifically for the Event)	Please List The Camera Bodies You Currently Use	What Type of Supplemental Lighting Do You Use For Low light Or Uneven Lighting Conditions?
How Many Copies of Backup Files We Make of My Original Images After the Event?	Will Any of the Backup Files Be Stored in a Separate Location? YES or NO	Will You Have a Second Shooter? YES or NO

TRUTH IN DISCLOSURE DECLARATION: PROFESSIONAL PHOTOGRAPHER

Optional: For An Additional Photographer at Event

Name	email address	Do You Have Signed Authorization From the Second Shooter To Provide Images to Me after the Event? YES or NO	Will You Allow Your Second Shooter From Using My Images for Advertising or on the Internet? YES or NO

Insurance Coverage

Amount of General Liability Coverage You Currently Have $	Amount of Errors and Omissions Coverage You Currently Have $	Amount of Equipment Insurance Coverage You Currently Have $

Event/Church/Facility Coordinators Who You Have Worked With

Name	email address	Name	email address	Name	email address
Name Of Venue		Name Of Venue		Name Of Venue	

Optional: Contact Information For Previous Paid Clients (Not Relatives Or Friends)
not required for photographers who guarantee privacy for clients, but preferred

Name	email address	Name	email address	Name	email address
or: URL for online viewing http://		or: URL for online viewing http://		or: URL for online viewing http://	

Testimony of Photographer

I, (the undersigned photographer), have carefully checked all of the answers above and declare that the information and answers provided above are completely accurate and truthful.

I agree to incorporate this declaration to any contract executed between myself and the undersigned client for photographic event coverage, and that this representation is accurate and truthful.

In the event that any of the representations made above are discovered to be misleading, untruthful or inaccurate, I understand that this document may be used in a civil action against me for misrepresentation and/or fraud.

Photographer _____ Date __/__/__

Client _____ Date __/__/__

Free downloads of both Microsoft Word and PDFs of the form are at:

http://tinyurl.com/garyfongphotogappform

Print out a copy of the form and give it to your potential client at the first meeting. This shows tremendous professionalism and goodwill, and helps to level the playing field for professional photographers versus amateurs posing as professionals.

The printed form, though, is only a brief summary of the types of issues clients should be concerned with. It's up to you to provide some additional background. The following points are important to discuss with clients, so they'll be able to separate the sizzle from the steak.

As you're educating potential clients on the world of professional event photography, try to communicate these points:

Your selection of a photographer will be the most important decision you (the client) will make in your wed-

ding. The photographer will be the custodian of your memories; long after the wedding day has passed. Experienced and qualified photographers are very aware of the level of expertise that is required to handle the pressure and unpredictability of your event and deliver quality images responsibly. Flashy newbies are not.

On the Internet, it's really easy to look qualified. There are many photography workshops, for example, in which working professionals hire stylists, makeup artists, and professional models; set up a shoot; and then direct the student photographers in collecting images to use in their portfolios. While the students technically take the photos, most of the artistic and technical content of the shoot is handled by the pro. But the pro's students can now use these shots on their websites as examples of their own work. It's misleading to potential clients.

Also, photographers often show just their best images culled from a large number of events, which makes them look more talented than they really are. After all, everyone gets an occasional good shot, just by sheer luck. An even more disturbing recent trend (as a Google search will show) is that a growing number of "Meagan Kunert's" are copying images of other photographers and putting them on their own websites as their own work.

Nowadays many "photographers" enter the profession lured by the promise of generous fees for what they think will be a single, easy day of work. And today's digital cameras are so automated that they can produce nice, predictable images during casual use. But the entire equation changes when it's a fast-moving, important event and there's no time to fumble with the equipment. That's when the pro really emerges over the amateur.

You (the client) don't want your wedding ceremony to

be put on hold while an insufficiently experienced photographer struggles with equipment during a critical moment. And you certainly don't want entire parts of your wedding day to be missed because the camera or the memory cards were not handled properly.

Keeping these points in mind, you (the client) should ask a professional photographer questions such as:

How many weddings have you photographed professionally? In order to charge market rate in your area, a photographer should have at least twelve full weddings under his/her belt. As a rule of thumb, you should subtract 10% off the price for every wedding less than twelve that the photographer has done. And the photographer should agree to this. So if someone has done only six weddings, they should be 60% cheaper than market rate (in your area). That would mean, for example, $2,500 = $1,000.

Have you ever had any mishaps where images were lost? If so, what caused them? This is a very important question to ask. The answer should, of course, be no. But sometimes a mishap early in a photographer's career can be forgiven, as long as the shooter has learned from it and made adjustments to his/her procedures.

Are all of your samples your own, and from actual commissioned clients? Were you a second shooter on any of these images? Are all of them from actual events or were some of the images "staged" or done with models? You're looking for assurance that most of the images were taken at actual, commissioned events with your candidate as the primary shooter.

At what resolution will you be capturing the files? Do you guarantee a base number of usable images per hour? What do you consider a "usable image"? It is your wedding day. The photographer should use the

highest megapixel resolution currently available – a minimum of 12 megapixels. The photographer should be able to quickly and specifically list the criteria he uses to qualify an image as usable.

May I see three of your recent weddings, with all of the images (including outtakes) unedited? As you review the images, look for the percentage of unusable shots (focus issues, exposure problems, etc.) and look for missing sequences from the day. Did the photographer capture the kiss at the ceremony? The more unusable and/or missed shots there are, the higher the chances that your big day will be recorded inadequately.

May I see a list of the equipment that you use regularly for paid assignments? (Please do not list equipment you plan to rent.) See the "minimal required equipment" in another part of this book as a basis for discussion.

Are your cameras full-frame or crop sensor? Crop sensors are acceptable. This means that the sensor size is 1.5 times smaller than a full-frame camera, but this is usually made up for in the megapixel count. The most important thing to note is whether the photographer even knows what you are talking about.

What type of supplemental lighting do you use in uneven lighting conditions? The answer should be multiple flash units, at least one on each camera, with a diffusion device attached to the flash head to prevent blown-out exposures and flat lighting. If they answer (as they often do), "I am an available-light photographer," this typically means they are not comfortable with flash photography, which takes a little more expertise. You want someone who's comfortable with both flash situations and available light situations.

May I have a list of paying clients, so that I can contact three of them for references? Insist on a list of true clients, not friends

May I have a list of three event coordinators that you work with regularly so I can contact them as references? Event coordinators (for example, at churches or catering halls) are a very valuable resource for information. Ask the: Does this photographer know what s/he is doing? Does s/he ever hold up the event for photography? Have past clients ever had complaints about the photographer?

How many backups do you make of the original images after the event? Where are the backups stored, and in what format? The photographer should back up the images (unedited) to at least two separately stored drives, with at least one DVD stored in a fireproof safe, or in an off-site location. This should be done after verification of reliable image transfer. The photographer should also keep your original flash memory cards untouched until all of the images have been verified online or in another electronic media format.

What type of insurance coverage do you have as a photographer? If your photographer loses your images or completely screws up your event, it's a waste of time to sue them if they have no assets. Make sure your photographer has insurance that can compensate you. The insurance should cover errors and omissions, and should include valuable papers and records clauses.

Will you have a second shooter? Do you have authorization from the second shooter to provide images to me after the event? What agreement do you have with the second shooter for use of my images in advertising on the Internet?

If I were to hire a drywall person, I would have no idea what questions would be helpful in the hiring process. So I would really appreciate it if a drywall expert gave me some insight on how to make a good decision. This is the service you are providing when you offer potential clients this brief education. Even if the client doesn't hire you right away, offering this service may lead to your being hired later or to new referrals.

Of course, during the interview, answer these questions yourself and jot down your answers on the form. Perhaps consider giving the client five blanks of the questionnaire so they can use it to take notes on other photographers they're going to interview. This will reassure them that you are not pressuring them, and that you are confident about how you stack up against the competition.

The purpose of these due-diligence questions is to help client recognize the professional divide between the un-trained newbie and the true pro who can deliver the goods. Without going through these questions, it is very hard to tell the difference between a pro and somebody who only appears to be one on the Internet.

Displaying Products
The Ideal Display and Sample Set

I've seen wedding photographers walk into client meetings with huge wedding albums and pile them in front of the client. Yes, the goal is to have the meeting go long, but not because you give them 80-page wedding albums to plow through. You want the meeting to go long because they keep talking about their event and disclosing more details as time unfolds.

In my early days, I used to seat clients on a sofa with a low table in front of them, and then bring over eight huge, huge albums, all in a pile. I had little success in booking with this approach. Think about it. There's the client, sitting on a couch, trying to suck their gut in, flipping quickly through these giant books because they know how many more they have to go through. It's totally boring. When they're done with the first display book, they think, "Okay great, one down, seven more to go!"

The only reason to show hard samples at this point is to demonstrate your product package options. Again, they've seen a lot of your work already or you wouldn't be doing the face-to-face. They're only here to see if your breath smells like garlic and if you and your studio look like they belong on an episode of Hillbilly Handfishin'.

And also to find out how much this is all going to cost.

If you're like most photographers (I mentioned this in an earlier chapter), there's a pretty good chance you are currently offering four product/service packages, running from "minimum" to "best." Photographers give them different names, but they're usually four different price levels. They usually break down something like this:

Minimum. *(names like "Limited," "Basic," "Carnation," "Petite") — usually includes just a few hours of coverage, one photographer, a small amount of product, and high-res digital files. Client is provided with one DVD.*

Standard. *(names like "Basic," "Standard," "Hyundai," "Princess," "Rose") — usually includes full reception coverage and some hard products such as basic albums or prints. Multiple DVDs.*

Extended. *(names like "Deluxe," "Cadillac," "Queen," "Hydrangea") — usually includes reception coverage and a larger assortment of hard products such as albums or prints.*

Premium. *(names like "Premium," "Rolls Royce," "King," "Orchid") — usually includes all of the above plus an additional photographer, extended time coverage (up to ten hours), an engagement session, a "trash the dress" (gag) session, a deluxe album, and perhaps some wall enlargements.*

The premium packages are rarely, if ever, booked. They're usually just there to add perceived value to the "Standard" and "Extended" packages, and for photographers to quote at conventions or other get-togethers when talking about their prices. If a photographer offers an $8,500 super premium package that has never once been booked, he can still claim to offer it. If a client ever booked the highest package, though, the photographer would probably do a face-plant on the floor.

While the photographer may want to book the "Extended" package, the client will normally book the "Standard" while trying to negotiate a price that comes closer to the minimum package. Clients will say things like, "Well,

what if we don't need that third hour"? Refer back to the chapter on Pricing Strategies for my sentiments about negotiating prices. I am not a major fan of the idea.

Nor am I a major fan of package pricing, as I discussed earlier. If you do choose to offer step packages, though, the client meeting is a good time to show samples of the hard product in the package. This will give the client a tangible idea of what the physical package entails. You'll probably notice that size is not particularly impressive to clients at this point. If, for example, your Standard package offers an album with 20 pages, and the Premium offers 60 pages, most clients will have little interest in the huge package. Why? Because it's 60 pages of photos of complete strangers. Before the wedding a large package seems excessive and unappealing.

After the wedding, that changes 180 degrees. After the wedding, the client is looking at their own images, rather than some attractive stranger's. The problem is, you've already limited the number they can choose. Trying to fit all of your fantastic images into their pre-sold package is a struggle for the client. This leads to frustration, of course, because the newlyweds don't want to pass up any nice images, but they're also not prepared to spend more.

This, again, is why I priced the way I did for twenty years; why I had pretty much the most financially successful studio I've ever heard of; and why I never once changed my approach. I didn't do pre-sold packages, I just let the couples decide after the wedding how many photos they would want to include in their selection. And I primed the pump by putting together nice pre-designs with lots of images connected in a story-like way.

Even if you have your pricing set up to allow the couple to select afterwards, though, you're still going to ask for a deposit, so it makes sense that the couple would want to

see what their prepaid deposit would cover. Show them a display album that is very close to the prepaid deposit. It will likely have enough images to give a great "highlight" reel of their wedding day, and the clients may think this is fine. For now. But—and I apologize for beating this point to death—after the wedding, couples won't want the high-light reel, they'll want the full feature-length film. For that, they'll gladly extend their budget, even by a factor of multiples. But if you hardwire a wedding package with a set number of prints, then no matter how good a job you do photographing the event, they will delete dozens of great images in order to arrive at the artificially limited number.

Another issue with preselected, pre-sized packages is that the higher the package price, the greater your temptation will be to throw in a lot of extras. This can present a huge problem because if the package is sold before the wedding, that money is often spent long before its time to pay the lab and the album company.

Cash-flow management is a huge problem with seasonal event photographers, and that's why I'm going to devote the next chapter to discussing this.

Money Management: The Evil Cash Flow Temptress

Handling huge chunks of cash properly takes a lot of discipline. Say you book a $3,500 package. Normally, packages are paid up-front (before the event) and the typical cycle between the booking and the delivery of the final products to the client is about four to six months. For an average salaried employee or wage earner, $3,500 is one-to-two months of after-tax income.

What happens to that cash in your hand? It becomes an evil temptress. It can quickly lure even the most strong-willed photographer's ship into the rocks. Think about it. If the average American carries a five-figure credit card debt, what are the odds that a newbie photographer will actually hold $3,500 in escrow for several months?

By in escrow I mean setting the money aside until the job is complete. You see, the $3,500 is not earned income until you've fulfilled the terms of your contract. So if your contract says that you will do X amount of hours in Y amount of sessions, plus provide Z number of finished images, then until you deliver the goods to your client, you have a liability on your books. The $3,500 is not really yours until the event is over and you've made good on everything. Legally, at any point before you've fulfilled your contract, the client could still cancel out and demand a refund.

The temptations to play fast and loose with your cash multiply greatly with the number of events you book. Say you are just starting out, and in your first year you find yourself with six weddings on the books, for $3,200 each. That's nearly $20,000 in your bank account that isn't even yours.

Hanging on to most of that money is clearly not Rockstar fun!

I've heard photographers make claims like, "I've only been at this one year, and I recently deposited $7,000 in my bank account in one week." Sounds like the best thing ever to post on the ol' bloggity. In this hyper-myopic Internet world where people don't read much further than the tag line, you could print the line below, and it would technically be the truth:

In My First Year Of Wedding Photography, I made $7,000 in One Week!"

Hmm. I can hear a workshop forming as I read those words. You sound as if you're achieving Rockstar income levels!

Now, what do you do with $7,000 in one week? Maybe quit the day job, tell the boss to take a hike? Perhaps. Or maybe spend it on things like hiring a "branding" consultant, or whatever must-have toys that tickle your fancy.

But be very wary. A typical photographer runs a cost-to-produce of greater than 50%. That means that if you blow the money now, there won't be any money left to pay for trifling things like, oh, the assistant, the upload charges, the prints, and the album book. Even if you offer no hard product, you still have to do the work. You have to shoot for an entire day. Then you have to go through the backup procedures to keep the files safe. Then you have to spend another two days editing the event. Until all of those steps are safely done, your client can still demand a refund for all kinds of reasons—a fistfight between the bride and groom, a sudden illness, a death in the family, etc.

Consider this all-too-real scenario:

You collect a $3,200 up-front payment for a wedding. The cash is giving you a contact high and you decide this might be just the time to buy a cinema display for your computer! After all, you are going to have to edit so many images, and your current small screen will sap your productivity. You also need a spare camera body, right? And that fast prime lens? You shan't shoot the next wedding with the lens that came in your camera kit! Not if you're on the Rockstar track, no way! Before you know it, Boom. Money's all gone!

Now...

You wake up the morning of the wedding with a really bad fever and chills. You can barely stand and your lungs are wheezing. There's no way you can shoot the wedding. So you have to contact the bride and break the news — which is awful in itself — and then you have to refund the entire amount. Where are you going to come up with $3,200?

Well, there's a couple coming in Thursday afternoon for a face-to-face meeting. Oh God, but your rent is also due on the thirtieth! (It seems like the thirtieth of the month comes around so fast these days.) So you need to book that next client, and get some cash in your hand, fast. In fact, you need to book this client so badly that you throw in an ultra large discount if they agree to book at the time of the meeting. They don't, of course, because you're scaring them away with your desperation!

This kind fearful neediness acts like a repellent that drives away potential clients.

Are You Unknowingly Repulsive?

In my previous book, The Accidental Millionaire: How to Succeed in Life Without Really Trying (available in retail bookstores everywhere), I dedicate a chapter to what I call the Law of Repulsion. It's the exact opposite of the phenomenon described in The Secret. In that latter book, the author describes the Law of Attraction, which states that if you clearly and powerfully visualize the things you want to acquire, the universe will deliver them.

There's a flip side to this "law," though. In my book I describe the aversion one feels when dealing with a really pushy, needy person. That's the Law of Repulsion. The basic premise is this: if you want something super badly, it seems the universe does everything in its power to whisk it away from you. For example, a car salesman desperately trying to make this month's quota won't sell nearly as many cars as a pleasant, helpful salesperson whom everybody loves for his friendly, relaxed, helpful demeanor.

Or... how about if you're turning thirty and are really anxious to get married? Your neediness will send potential suitors running for the door. It's also well known that couples unable to have children after years of intense trying seem to suddenly get pregnant the minute they decide to they adopt. (I know that one firsthand, as my twins can testify!)

In The Accidental Millionaire I describe how crazy I was about goal setting in my early twenties. This colorful southern gentleman named Zig Ziglar fascinated me. I played his motivational tapes over and over in my car. These tapes taught that success only happens when you have clearly set goals. Ziglar explained that the way to

achieve your goals is to: (1) put them in writing, (2) set a deadline to achieve them, and (3) put leverage against yourself so that the goal has to happen.

My goal was to have $100,000 in my savings account by the time I was 30. By earning a lot and spending very little for six years, I came close—but was shy by $14,000. When my thirtieth birthday rolled around and I didn't hit my goal, I was crushed. Zig said do not accept defeat. You must achieve your goals, and you will achieve them if you follow the three steps above.

What he didn't mention was: What if your goal is simply unrealistic?

Let's say I set a goal right now to be a world champion figure skater within six months. Would putting this in writing get me there? Would the six-month deadline help? And what if the leverage against myself was a postdated check for $50,000 to the American Red Cross, which they could cash if I didn't reach my goal in time? Would that put me on the champions' platform?

That's the part Zig skipped. And it was crucial information for a blindly ambitious young man who was desperate to not wind up living in poverty like his parents.

It all came to a head for me when a bride came into my studio wanting to hire me for a wedding on a prime June weekend. She informed me that she was ready to sign, and as I was typing up the paperwork, I asked her when I could meet the groom.

"Oh that's a funny story," she replied. By then I was used to funny stories—so many I ended up writing a book about them. But what could be so funny about meeting the groom? That he was really a she, in a same-sex wedding

(been there, done that, ho hum)? That he was Boffo the Circus Clown? I guess that would be a little bit funny. Kind of.

"I haven't met him yet," she continued. My fingers stopped typing. She went on to explain that she was a follower of Zig Ziglar (oh no) and that she planned to be married by age 30. Her thirtieth birthday was in July, so in order to get married before then, she: (1) set a deadline, (2) put it in writing, and 3) put leverage against herself to make sure the goal would be achieved in time. What kind of leverage? Well, she literally booked the whole wedding—bought the gown, hired the band (a great one), reserved top-notch locations, catering, flowers, the works. All without a man in the picture yet.

I guess I was staring at her by the time she got to that part. "What? Do you think I won't be able to find a man in time?" she asked. No, that wasn't it. Clearly she could find a man. She was very attractive, well groomed, had a nice Chanel bag and heels. But I couldn't help wondering what this poor dude would say when she asked him on the first date if he wore a 42-regular tuxedo. Because, it turned out, she had actually reserved that too!

I didn't take the booking, explaining that my fee was contingent on how many great images I could produce in a beautiful storybook album layout. And I felt that the lack of a groom might create a slight void in the story line.

I never found out what happened with her. Maybe it all worked out and my theory is flawed. But I'd be shocked to learn that she found a husband by her pre-scheduled wedding day, or, if she did, that they're still married now. Law of Repulsion and all.

Focus on the Process, Not the Goal

As for me, the goal-setting steps of the wise Zig Ziglar were causing me only frustration and despair. I had become so goal-oriented I was driving myself crazy.

Then, suddenly, my own marriage ended. Not only did I fail to make the six-figure goal by my thirtieth birthday, but also thanks to my ex-wife's attorney, I was now hundreds of thousands of dollars in debt to her from my future earnings! With my entire life seemingly falling apart in front of my eyes, I was so absorbed in my own problems that I nearly rear-ended a Subaru at a stoplight. Then I noticed the car had a bumper sticker that read, "Since I Gave up Hope I Feel Much Better."

As soon as I read those words, I laughed out loud until I started to cry. It felt like a message intended for me alone. I needed a new life philosophy very badly at that moment, and the bumper sticker gave me one. I decided to take its message seriously. I decided it was time to give up hope.

At the time I had a studio manager covering my contracted events, so I dropped out of civilization and headed for Club Med in the Bahamas. I spent nearly two months there, eventually becoming one of the tennis instructors. I gave up any ideas about success, or goals, or pretty much anything else. After all, with hundreds of thousands of dollars due to my ex-wife from my future earnings, what incentive was there for me to work?

Well, I got all of that crazy gypsy stuff out of my system and finally decided it was time to go back to Los Angeles. When I got there, with my head clear and my spirit refreshed, my creativity suddenly exploded. It was as if I was able to see, for the first time, all of the opportunities

that were always right in front of me.

In that era, nobody made software for designing photography albums. So, along with a programming partner, I co-created a software program called Montage. We wound up making millions of dollars on that product. Not only did I take care of my debt, I generated a pile of savings—far greater than my original goal of a hundred grand.

Then it dawned on me. I had never set a goal to make over a million dollars as a software developer before I was 31. Yet it happened without really trying.

So this philosophy started to permeate every sphere of my existence. I didn't obsess about the outcome of anything, and I found the less stressed out I was, the more successful I "accidentally" became. I had no idea how to explain this magical "non-formula" to friends. In fact, the publicist for my Accidental Millionaire book suggested that I consider labeling myself the world's first "non-motivational" inspirational speaker. Don't know how far that would go in the Twittersphere!

But taking goals out of the equation really worked for me. And the reason is this. Obsessing on the outcome becomes a distraction from the process of taking the effective steps necessary to create success.

I remember once I was a volunteer in a Los Angeles emergency room when a large multi-car accident brought in a wave of critically injured people. I watched the doctor calmly and confidently select the patient with the gravest injury and the best hope for recovery, then work as fast as he could on that person and move on to the next patient. He did a truly amazing job.

When it was all over, I asked him, "How were you able

to not freak out, knowing that you were making life-and-death decisions for all these people?" I mean, this man was basically deciding who was going to live and who was going to die, and I couldn't figure out how he was able to do it so coolly. He told me something I'll never forget. "Under conditions of great stress," he said, "you need to focus on the process, not the outcome." And so, even though mayhem was swirling all around him, he remained calmly present, watching his hands go through his well-trained procedures. He focused completely on the process and not on the burden of deciding the destiny of multiple lives.

Goal setting was the problem that had been wrecking my life in general. As soon as I give up hope (i.e. expectations), everything started to fall into place in a miraculous way. Life spontaneously presented me with opportunities I would've missed had I been focused on a particular outcome.

For example, I gave up on relationships, deciding that I was completely fine with being single for the rest of my life. That's when I met the love of my life that is now the mother of my twins. I gave up on financial goals, and yet one opportunity after another began popping up to make me very wealthy.

I never set a goal to be a published author, either. I just started talking into my iPod's microphone, recording some of the hilarious things I've witnessed in twenty years of wedding photography and other business ventures. Before I knew it, my book was sitting in the biography section, sandwiched between Jane Fonda's and Michael J. Fox's.

If you're curious to read more about my "accidental" philosophy, just go to your favorite book retailer and purchase it, and I'll thank you in advance for the $2.17 royalty!

Having Savings Calms Those Nerves

Although I heartily endorse and live this goal-free, hakuna matata philosophy, I want to use this book to focus on very mechanical, not ethereal, solutions to achieving success. And the most important thing you can do—this will help you with your bookings, with the rates you charge, and with your entire "neediness" level—is to save money from your photography activities.

Saving money may sound boring, and it may not be the advice you get at the Rockstar seminars, but it will actually buy you freedom and control like nothing else can. You don't need to have a dollar goal; you just need to commit to saving as much as possible.

In my early days as a photographer, when a large check came in, I spent very little on personal luxuries or anything flashy. In fact, in those early years I juggled floppy disks instead of purchasing a hard drive, even though I could easily have afforded one. And when I began making hundreds of thousands of dollars per year, I still drove a used Mercedes station wagon. Everything that came in, I tried to put into a savings account. Everything that went out was the bare minimum I could get away with spending.

These lessons were pounded into me by my grandfather, then my dad, who constantly hounded me about savings. He always used to say, big deal, so you make a lot of money—how much do you have in savings? My first year, I earned $64,190 and I told him that. He said, big deal, how much did you save? (Answer, $16,000). He chewed me out pretty good on hearing that. He asked, "where did you

Sunday, March 3, 1985, Los Angeles Herald Examiner D15

MONEY PORTRAIT

At 24, this photographer is married to his business

By Gregory Spector
Herald staff writer

A year and a half ago, Gary Fong had $30 in his checking account. Today, the 24-year-old has $16,000.

Although he has a degree in pharmacology from UC Santa Barbara, the only white jackets in Fong's life nowadays are worn by members of bridal parties. He is founder and owner of Marina del Rey-based Storybook Weddings Photography, a successful business that brought him $64,000 in income last year. And based on bookings for the first quarter of his fiscal year, the business should generate at least $120,000 in 1985.

"A few years ago while reading Life magazine, I found an article about a successful wedding photographer who I knew as a kid," says Fong, an only child who grew up in an upper-middle class home in the Playa del Rey area. "I saw that he was doing really well, so I went to his studio and became his apprentice during the summer before my senior year in college."

Following graduation in June 1983, Fong moved back home to Marina del Rey and opened for business in his parents' apartment.

"We've turned my bedroom into a really nice office overlooking the Marina — right on the water," says Fong. "And my customers seem to like the informal setting."

The arrangement is fine with his parents, and all of his photo processing is done by an outside lab, which picks up and delivers twice a week.

Fong says he has all the photo equipment he needs for at least 10 years and has no intention of moving his business from his parents' apartment — even after he marries his college sweetheart in July.

Because he still lives with his parents, he has no food expenses, but he contributes $6,000 a year toward their rent.

Fong said he will continue to help with his parents' rent once he marries, but he and his wife-to-be plan to rent an apartment of their own, also in the Marina del Rey area, which he expects to cost about $1,200 a month. In addition to paying more for rent and food, he will also have to furnish his new digs.

Since graduating, his "vacations" have all been business-related, but Fong says he doesn't feel he is missing out on anything.

"There is nothing I would rather be doing right now in my life than making this business grow," says Fong. "Anyway, there are too many things to do right now that I really couldn't take off on a normal vacation."

A self-described "conservative" when it comes to investments, Fong has few short-term financial goals except to build his business, reduce his tax liability and sock away $40,000 to $50,000 in liquid savings.

Three years out, Fong says he would like to be investing in commercial real estate — apartment units, something that produces income. And although he and his wife-to-be intend to have children, that probably won't be for another six years.

Beyond three years, his financial goals become fuzzy.

"I've just had a gigantic jump in income, and although I do a lot of reading on money management and taxes, I don't have much actual experience," says Fong. "There's guys calling me all the time about crazy investments. I've just heard of too many people who blew their money and I don't want to do that."

A professional planner frames his next shots

The Herald asked Jon Mandell, a certified financial planner with Associated Planners Securities Corp. in Torrance, to help Fong plan his finances.

Mandell says Fong already demonstrates the financial maturity expected from someone 10 to 15 years older. Fong is headed in the right financial direction, has a good business plan and clearly has the expertise to make money. All he needs now is a plan to position his money with the correct emphasis and priorities.

First, Mandell says, Fong needs to open an Individual Retirement Account for 1984 — preferably in a professionally managed, aggressive-growth mutual fund. For '84, Fong qualifies for up to $2,000 in federal tax deductions and $1,500 in state deductions. The combined tax deduction should save him about $980 in actual taxes for 1984.

An alternative to the standard IRA is a Simplified Employee Pension plan IRA. Fong would qualify for an investment of about $5,700, which would save him $2,150 in taxes.

Next, Fong needs professional and personal liability coverage. The rock-bottom minimum would be $10,000, but $1 million would be better, which would cost about $800 a year. Fong also needs to upgrade his auto insurance to 100/300/50, adds Mandell. The premium on that would be nominal — maybe $20 more a year than what he is already paying.

Disability income protection is also a must. Fong should think in terms of $1,500 a month in disability income, with a 30-day elimination period and coverage for at least five years. Cost approximately $450 a year.

With these essentials taken care of, Mandell says, Fong can start mulling over his future finances.

The planner says he should start thinking about opening a Keogh retirement plan before Dec. 31 — preferably a "profit-sharing" rather than "money-purchase" pension plan. (A profit-sharing Keogh has a voluntary annual contribution. A money-purchase Keogh requires a commitment of a specific amount each year, whether you make a profit or not.)

That way, Fong can set aside up to 15 percent of his net business income, as well as another $2,000 in his IRA. The Keogh, however, eliminates the ability to deduct his IRA on his state tax return. But Fong's estimated total tax savings would be about $2,950.

Once married, Fong should hire his wife and pay her at least $2,000 a year, which she can invest in her own IRA as a tax deduction, while he can deduct her wages as a business expense.

In light of Fong's conservative nature, Mandell suggests sinking about 60 percent of his liquid funds into a professionally managed portfolio of California municipal bonds as a good back-up to his Cash Management Trust account. A California portfolio currently earns almost as high an interest rate as his CMT account, and the interest would be completely tax-free.

Another 10 percent or 15 percent of his money might be put in gold-mining shares as a hedge against financial crisis. The rest could be put into limited real-estate partnerships to fulfill Fong's plan to invest in commercial real estate. With an investment of as little as $3,000 to $5,000, all of the benefits of real-estate ownership accrue to the investor, without the day-to-day management problems.

Mandell would also like Fong and his wife-to-be to have token amounts of life insurance. Each can purchase some $100,000 of term insurance for less than $130 a year. Cash-value type life insurance should be avoided.

Gary Fong in his Marina del Rey studio: "I've heard of too many people who blew their money."

BOTTOM LINE

GARY FONG

ASSETS:	
Cash mgmt. account	$13,500
Money-market account	7,650
Loans	8,300
Automobile	11,692
Automobile telephone	1,496
Office equipment	3,840
Camera equipment	8,378
Accounts receivable	6,300
Professional library	658
Inventory, film, supplies	650
TOTAL:	**$58,104**

OBLIGATIONS:	
Student loans	$4,887
Automobile loan	5,0P-
TOTAL:	**$10,640**

NET WORTH:	$45,464

INCOME:	
Sales	$51,000
Fees	13,000
Interest	400
TOTAL:	**$64,400**

EXPENSES:	
Rent	$6,000
Accounting, legal fees	348
Advertising	1,530
Camera insurance	232
Photo finishing	17,000
Telephone	3,000
Other business costs	4,029
Automobile insurance	1,217
Automobile expenses	824
Charitable contributions	750
Clothing and cleaning	1,271
Entertainment	1,400
Interest expenses	1,275
Medical insurance	520
Income tax, Social Security	6,000
Savings	17,130
Bank service charges	207
Sales tax	1,566
TOTAL:	**$64,400**

blow the 50 grand?" - and I had no answer for that. The next year, I did much better, putting away about half of $121,700.

Staying focused on my savings account not only took the pressure off of having to pay extra bills or large car payments (I pay for my cars outright rather than finance them); it took the pressure off me as a businessman. And this has been a huge benefit to me throughout my career. Any job that popped up, I could take it or leave it, so this meant I was able to be selective about choosing my clients. Clients were never booked as a desperation measure for immediate cash flow needs. In fact, I have never once—ever— offered a client a discount from my published rates. Not once.

I didn't have to work with anyone I didn't want to, and I didn't have to jump through hoops to get business. When a client came to interview me, my attitude was: while I would really like to get the job, I can survive without it. My savings account was a beautiful antidote to the Law of Repulsion. It kept desperation at bay.

By the time I was forty-two, I had enough in savings and real estate to retire from shooting, a self-made millionaire from, of all things- wedding photography.

This is the exact opposite of blowing your deposit money. As a seasonal wedding photographer, you'll have some months where the cash flow is huge (typically the fourth quarter of the year). Many photographers will take that cash and buy fancy cars or clothing, especially in today's world of "prosperity" blogging. Don't be one of them.

I remember during one particularly profitable year, I showed up at a get-together with other local photographers in Los Angeles. I pulled up in my five-year old Jeep Cherokee and parked next to all the leased BMWs and Mer-

cedes. Although I easily could have afforded any high-end car of my dreams, I had resisted the temptation (until the cost of a really high-end car became a fairly trivial matter for me).

A large savings account was one of the best advantages I ever had in business. So my solemn advice to you, no matter where you are in life, is to always live well below your means, and to make every purchase decision sparingly. Even when money appears to be flowing in like crazy, resist the urge to blow it.

To the extent possible, earn as much as you can, save a lot, and spend nothing. Of course, that sounds like "eat your vegetables" advice but I'm telling you that keeping a low overhead, high savings, and small expenditures will help you to have a relaxed attitude with clients. Because you're not stressed, you'll be a lot more confident and pleasant to be around, and that's attractive to clients. You will do much more business as a result.

Clients can sense a desperate photographer just as an attractive woman can sense a man desperate to get laid. There's energy in a needy person that raises the hair on the backs of our necks. It's extremely confining to be limited by a constant need for cash flow. It's extremely liberating to not be.

I've sometimes made errors in business that has cost me hundreds of thousands of dollars. Every once in a while I think about those decisions and wish I could turn back the clock. It's impossible to hit "replay" with your life decisions, so the best you can do is to learn from mistakes and avoid doing the same thing in the future.

And the biggest mistake to avoid is blowing cash.

FisheyeConnect.com has created a free photographer's pricing widget that you can use for budgeting. One of the

hardest things to do, with any seasonal business, is to manage cash flow, budgeting, and expenses. By using the widget you can set clear budgeting goals. You can also see the effect on the bottom line if you shoot X number of events at X price.

The other thing I recommend is to pay yourself a reasonable amount as soon as you start seeing positive cash flow. Get used to earning a certain paycheck every month regardless of how many sessions you shoot or don't shoot that month.

Shooting Tips: Helpful Advice For The Big Day

Now I'd like to share some miscellaneous tips and insights that will really help you distinguish yourself as a thoughtful, trustworthy pro before, during, and after the wedding. Again, these are lessons it took me years to learn, but you can learn them just by flipping these pages...

Introduce Yourself to the Flower Girl First

Imagine you're the flower girl, and for weeks before the wedding, everyone's telling you how pretty you're going to be, and how important it will be to look good for the photographer.

Then, on the wedding day, the person with all of the bags and cameras zips right by you and heads for the bride, as if you're invisible. And for what seems like hours, the photographer busily snaps the bride with an endless parade of grownups, making a huge fuss over how gorgeous she is. Then, finally, at the end of all this, it's your turn.

No wonder little kids cry when we bring them in for photos. They're confused and frustrated.

After years of inserting the flower girl (or ring bearer) at the end for portrait combinations, I realized I had it backwards! These poor little kids are all hyped up to be super important, they have a pretty dress on, and they're carrying a beautiful basket of sweet-smelling flowers. Why is nobody paying attention to them?

Armed with this insight, I began greeting the flower girls and ring bearers first. It just takes a moment to make a child feel special. I would make a big deal of each of them individually, complimenting them on all of their little

details, with phrases like, "What a beautiful dress," "Can I see your flowers?" or to the ring bearer, "Wow, you look so handsome!" Then I'd photograph the kids with the bride first.

When the kids are done first, they don't have a chance to mess up their outfits (I've seen flower girls rip their headpieces off during meltdowns) and everybody feels more relaxed. Typically the kids are children of the bride's siblings or best friends, so the parents are stressed out, too, when the children get rambunctious before they are photographed. Once the kids' photos are in the can, everybody is happy and relieved. Usually after they're photographed, the kids even enjoy sticking around to see everybody else having their picture being taken. If you photograph them last, not only will you blow a chance at a great photo before the ceremony, but also they'll suffer embarrassing meltdowns during the ceremony, wrecking the vows.

Bring a Notepad to the Wedding

During all my years of shooting weddings, I always took a pen and notepad along to jot down little notes during the day. For example, if the reading were first Corinthians, I'd write that down. Then, when I was designing the album, I might add a few words from that biblical passage as a caption under the otherwise-boring photograph of a reader at the podium. It adds another dimension to the storytelling when you can sparingly and tastefully include a few words under some of the photos.

If the bride was a member of the Delta Gamma sorority, I would jot that down in my notepad, and then maybe later get the lyrics to that sorority's song, and sprinkle a few of those words in a couple of places in the album. Anything

to make the product personal and meaningful.

Here's a little story about how effective taking notes can be. I shot a wedding once where the bride got dressed in the same room her grandmother had used nearly sixty years prior. The dressing room had been completely re-modeled and modernized since then. When the bride ex-plained this to her wedding party, she mentioned that the one thing left over from the original room was the door-knob

So I pulled out my pen and jotted a quick note, "door-knob—grandmother." And then, with the event fresh on my mind on Monday, I sat down at my computer and made that doorknob the opening page of the entire album.

When I presented this highly personalized pre-design to the bride, she actually yelped. With her mouth wide open, she asked me, "How could you possibly know how im-portant this doorknob was to us?

I said, "Well I was taking notes at the wedding to help make your album more personalized." From that moment forward, all hesitation about how many images to purchase was thrown out the window, and the bride was totally in love with me.

One thing a girl really likes in a man is one who remem-bers all the little details. Apparently this breed of man is quite rare, so taking notes at the wedding (whether you're a man or a woman) will instantly make you a cut above everyone else.

I got tons of "rave referrals" from this album, because her friends and family remembered me as the guy who re-membered the doorknob!

Once I became "that" photographer, the bookings came flooding in. I wasn't just another shooter in the crowd trying to compete for business by price. I was the specific photographer people wanted for the thoughtful type of wedding albums I produced.

Try To Avoid Having A Standard Checklist

Visit any wedding photographer's blog on their website, and you will most likely find the following photos:

- *Bride's Gown Hanging on a Coat Hanger*
- *Bride's Heels on a Table, Back to Back, Like "Bookends"*
- *Bride's Wedding Ring Stuck in Stamen of a Flower*
- *Close-up of Bouquet Alone, Being Held by Bride in Front of Her Waist*
- *Close-up of All the Bridesmaids' Feet With Heels on, in a Semicircle (or Groomsmen's feet in socks)*
- *Close-up of Centerpiece at Reception*

 ...and Cake Knife

 ...and Placeholders

 ...and Table Setting

 ...and Cake Detail

 ...plus Cake Top

Because the standard list of images above is so prevalent in everybody's online photo galleries, photographers usually bring this checklist with them (either memorized or on a little reminder card) so they don't forget to shoot all of these "compulsory" images.

That is not necessarily a bad set of images to offer.

However, the photographer often arrives at the event armed and ready to tackle the shot list first. I've seen photographers breeze in and immediately ask where the gown is, ask if there's a credenza to hang it on, then ask the bride for her heels to do the bookend photo... This goes on for the first half hour while precious spontaneous moments are being missed all over the place.

I've never gone through a shot list. My opinion is, I'm there to tell a story, not to fit the clients' wedding day into a preconceived template of "My Greatest Hits, Repeated Ad Nauseum." If I'm moving around, and I notice the gown hanging on a credenza, of course I'm going to shoot that. But in the context of other things. The whole time I'm watching the event like a Secret Service agent, scanning from left to right, ready to pounce on fleeting moments. Storytelling is not the same as shooting for your blog. It's more creative and spontaneous and client-centered. And it's a developed skill that can make you really stand out, because you are not the cookie-cutter photographer who copies from other people's copies of other people's copies.

Be an Original

In fact, I think you are doing yourself and your client a major disservice by having a rigid game plan in mind before shooting. I've often joked about how all engagement session shoots start at railroad tracks with the couple walking toward the camera, then show the couple walking away from camera, then the guy dipping her with her foot up and her toe pointed, then a close-up of just their hands with the train tracks in the distance, followed by a shot of the couple jumping. Then the couple proceeds to the graffiti wall for some "grunge" photos.

Someone creatively invented this series of shots, which was original at one time, and then everyone copied it. The repetition of such contrived images, client after client, repeated weekly, will make you sick of your camera.

Why not meet your clients at a completely random location with no game plan? Pick a spot on a street map, and ask your client to meet there! Or use Google Earth to locate an intriguing landscape. Try some long lenses, selective focus, whatever. Incorporate the elements of the location into something with visual impact. You will find that your creative juices and your technical expertise will expand, and you'll be proud of your work with each new session.

On YouTube I currently have over 200 instructional videos teaching lighting and technical photography skills. Do a search for my channel, "GFIGARYFONG" and look for a series called "Ugly Room Series." I literally put a model in front of a men's room door and turned that area into a beautiful portrait location! Then I took the poor girl to a parking lot (on a rainy day no less) and did a series of dramatic portraits there, with high-impact lighting and powerful cloud patterns. This series has been really popular, but I fear that it will spawn mindless imitation. Pretty soon,

photographers will be asking clients to meet in front of a men's room instead of in an empty field with a vintage couch!

By the way, do a Google image search for "Vintage Couch Portrait." At last count, this returned 578,000 hits. All portraits of people sitting on a couch in the middle of a desert or a grassy field. Is this creative? Or just copying?

The joy of photography lies in the growing of your skills and your vision in image making. If you are one who follows other blogs to get ideas on how to create images for your own blog, then you are not a chef, you are reheating leftovers.

Copying the images of others, or taking shooting workshops so you can obtain pre-staged images to fill your portfolio is reheating leftovers, too. It may seem like a "Fast Track" to professional success, but no musician ever became a Rockstar by playing Top 40 hits. Those musicians wind up playing at weddings, right next to Rockstar wedding photographers.

And now I'd like to share a story that might be the most important lesson in the book.

Crisis Management:
How I Handled the Loss of an Entire Wedding

Eventually it will happen. No matter how much care you exercise in handling your image files (or negatives, in the days of film) safely and securely, there will come a day when the stars are out of alignment, all the traffic signs are red, and the universe decides to cheerfully kick your ass.

Things will get bleeped up big-time.

I'm the type of person who prepares. If you had visited me when I lived in LA, you'd have seen that I had emergency food and water rations on my yacht to last for 30 days. I figured if things got really crazy in LA, I would just take my yacht out to international waters and wait for martial law to be lifted. (I lived in the city during the riots and some massive earthquakes, so there were some good reasons to be a bit "twitchy.")

But it got more involved than this. I knew that if Southern California went all Lord of the Flies on me, I would want to get to my homes in British Columbia as soon as I could. I've seen what the freeways look like when a city is evacuated, and I knew that a motorcycle would get me to Canada faster. So, get this, I bought a Honda Gold Wing motorcycle, and had it camouflaged to look like a U.S. Army bike. Knowing that gas might be not available (because the evacuating people would quickly deplete the supplies), I packed a siphon in one of the saddlebags so I could suck up gas from abandoned vehicles. I'm telling you, I thought this through.

The saddlebags were also filled with emergency water

and food rations. These food rations come in foil bricks and taste like corn bread mixed with sand, compacted in a car crusher, and doused in movie-theater butter. They provide, like, 2,000 calories per brick, and each brick is about the size of a disposable camera. One brick is supposed to last you one day. I had thirty of them.

What else was in the saddlebags? Oh yes, the Mylar "foil" space blanket. If you read Accidental Millionaire, you'll recall the one I had when I was ten years old and conducted my brief experiment in planned homelessness. Same deal. It was thin, crinkly, loud, silver, and bore no connection whatsoever to the word "comfort," but was supposedly designed to keep you toasty in the event of a nuclear holocaust.

I also had a stun gun. A set of Nunchaku sticks. Cans of Sterno cooking fuel. And a ceramic Glock 45mm handgun with cyanide-tipped bullets and a silencer. Okay, just kidding about the handgun; my name's not Delmont and I don't spend my weekends wearing a gas mask and hiding out in a root cellar with canned beans and a ham radio. But I am far more "cautious" than the average bear.

Even our horse ranch, today, has state-of-the-art security, bulletproof glass, and a pulsating sound alarm that can literally shatter the eardrums of an intruder once it is set off. There are hidden live cameras everywhere, and a secret deadly surprise should a bad guy visit us when we're at home. Hmm, maybe my name is Delmont...

I'm telling you all of this to give you a sense of how careful—okay, paranoid—I am. I am doubly so about my photo images and backups, as you might have guessed when

you saw my incredibly detailed preflight checklist for digital images earlier in this book.

In the days of film I was even more paranoid. Film was delicate and unpredictable. I always carried exposed rolls on my literal person, as in "You can have my client's wedding film over my dead body." I treated every client's film as if it were shot from the grassy knoll on November 22, 1963. I also took extraordinary care and safety measures once I got it back to my studio.

When we sent the film out for developing in our Northern California lab, it always went UPS, because that was the most reliable service. We would ship it in one of those lunchbox-sized "fireproof safes" that come with a key and have a carry-handle on top.

Biohazard Film Safe

Do you know where your film is right now? There is no loss greater than the negatives of your client's wedding. You can never be too careful with your film; yet most of the time it is vulnerable to damage, fire or theft. When you transport your film to the lab, it probably is in an unprotected paper bag or cardboard box. We put our film in these inexpensive paper safes to give to our lab delivery driver. Built to withstand heats of over 2,000 degrees F, they are so highly insulated that they will keep film cool and safe in even the hottest car trunk.

• If there is a car accident, your film is protected. Since this looks like it may carry cash, it is emblazoned with a "BIOHAZARD" warning to prevent theft.
• Each safe comes with two keys to prevent tampering: one for you, one for your lab.
• Your lab will treat your film with the utmost care when you show how serious you are about its' safety.

As you can see from this slide I used in my old lecture days, each of these safes was designed to survive heat up to 2,000 degrees (in case the vehicle it was being shipped in went up in flames) and sported a "Biohazard Warning" shield to discourage thieves from opening it in case it was stolen during a carjacking. I gladly absorbed the high cost of Next Day Air for shipping these heavy things back and forth.

So what more precaution could I take? None that I could think of.

Still, the gods like to remind Man that perfection is not within our grasp on this mortal plane.

I lost an effing wedding. It was the only one of my entire career, and one too many.

As soon as I found out the film did not reach the lab the next morning, alarm bells went off in my head. When we asked for a copy of the signature from the lab, UPS sent a scan, but it was from the next building over. At first, we were hopeful that they just delivered it to the wrong address and the erroneous recipient would quickly notify UPS.

I waited two more days before I felt sure it had become a "situation." (This was in line with the way missing persons cases are handled—the cops don't consider it suspicious until the person is gone for 48 hours, then they get involved.) When 48 hours had gone by with no sign of the film, I called the client.

This was a crucial step. It is very, very important that you notify the client the moment you discover a definite problem. I can't stress this enough. The big reason people get sued or thrown in jail isn't that they make a mistake, it's that they try to cover it up. Like Martha Stewart. Yes, she committed a crime, but she got the big sentence because she made false statements under oath. Or Toyota a few years ago. The company could have owned up to a problem with its cars sooner rather than later and averted a monumental public relations fiasco.

Being evasive is really damaging to any trust your client might have in you. Calling them at the first possibility of a

problem puts you on their side. You become a team work-ing together, rather than a client trying to "extract infor-mation" from an evasive photographer who won't return phone calls.

I called my bride and factually described the situation exactly as I understood it. I didn't guess at things I didn't know, nor did I offer phony reassurances (e.g. "I'm sure it'll turn up...they always do!"). I explained that UPS had collected someone else's signature for our package, and that our lab never received it. Then I gave the couple my game plan:

1) I would cancel all client appointments for the upcoming week. I would commit all of my business hours to locating their film and nothing else.

2) I would make every effort to locate the film. This would include flying to UPS's lost and found facility in Arizona. (I never ended up going, because I found out the place prohibited outsiders.)

3) I would call them at 5 p.m. every weekday with a situa-tion report, telling them what efforts I made, and what I had found out. Of course, I would also inform them the minute their film was located.

I followed through as promised. For a week, I did noth-ing but detective work. One critical step I took was to learn the route the driver used and contact every single address on his route. I didn't assign this task to any of my staff members; this was my responsibility and I took full owner-ship. This turned out to be a great strategy because one of the retailers actually found a ripped piece of cardboard with our air bill on it in front of their store!

That retailer was kind enough to dig through his trash and save it for us. Good thing I called when I did. Had I waited a few hours more, his trash would have gone in the Dumpster. That ripped piece of cardboard would turn out to be a very important piece of evidence in our lawsuit against UPS.

I contacted the client and informed her what we had learned. When we got the piece of packaging in hand, we noticed it had a dimply pattern on it. I sent it to a former client who was with the DA's office in L.A. This guy, in turn, had an associate in forensics write a report on the re-covered paper. The report, which would later stand as ev-idence, determined that the paper's dimply pattern was the result of being run over by a car on an asphalt street.

So this we knew: the box had broken apart and pieces of it had been run over about four miles before the location where UPS claimed to have delivered the package.

And here's what really pissed me off. Even though the driver had punched the name of the lab's neighboring business owner into his electronic signature pad, the signa-ture was not authentic. It had been forged.

So here's my theory. The driver failed to close his door properly (or left our package on his rear step bumper by mistake) as he drove off. The box fell out on the motorway, where it broke apart and got run over by cars. The driver, noticing that he had an air bill in his electronic pad, but no package to go with it, went to the next location on his de-livery route, asked the name of the person there, punched that name into his record, and signed the name himself.

The gods then decided to throw out a lifeline to me by blowing a piece of the run-over packaging, with our name on it, into a retailer's front door.

I had a lawsuit on my hands and I knew it. But that wasn't important. Yet. The priority was finding the film. We knew the box had busted apart, but, remember, I had packed the film one of those crazy-ass safes. It was entirely possible, even likely, that the safe had survived and was in someone's possession.

We waited another week, contacting every retailer on the route, but nobody had seen it. I called UPS, and they bigheartedly offered to replace the cost of the film! Wow, thanks, guys. That was about $300 retail. I guess they figured it was a major courtesy to give us $200 more than the typical $100 they usually doled out for lost packages.

The bride was furious at UPS. But here's the thing: she loved me. She remembered how hard I had worked on her wedding day, staying until the very end, and she remembered how I'd cackled with delight at some of the images. Most of all, she appreciated how honest I had been with her about the film loss and how diligently I had worked to solve it.

I told her that since I was the official shipper, I would file suit, but all of the recovery money would go to her and her husband. Obviously, I cut them a check for an entire refund of their payment to me. Though my contract stated that my maximum liability was a refund of all fees, I wasn't about to whip out the contract. I was on the same team as my clients, and we pulled together.

I took UPS to small claims court, and won the maximum

allowable $5,000. As we waited for the check to come, though, we got a lovely surprise from UPS. They were appealing the decision. So now we had to wait to have the case reheard at LA Superior Court, and the court date was nearly a year after their wedding.

During that time, I contacted the couple's guests and asked for their wedding negatives. I had proofs made of all of them, and designed a storyboard to create an album layout for them. Most of the images were woefully bad, but I found a small number of daylight shots I could use in the book. The selected images were then sent to a custom printer, for "dodge and burn"-style manual printing. This was very expensive.

I then did a re-shoot portrait session. Three months had passed and the bride was now pregnant, so I paid to have the dress altered. I also covered the cost of the tuxedos and the flowers, and we all met at my studio for group and individual photos. As you can imagine, this was not cheap— I was probably out of pocket five figures by this time—but it was the least I could do. The cynical businessman reading this might say, "Well, Gary, you saved yourself a lawsuit from the couple, so that must be why you did all of this."

That's not the reason I did it. I did it because I was fortunate enough to make a generous profit from my regular clients, and I really loved this couple. These folks were two referrals deep, but they were wonderful, peaceful, religious, and loving people. I hated what had happened to them.

Finally the day came and we appeared at LA Superior Court. I had represented myself in small claims court,

and, by this time in my life, had spent so much time in a courtroom that I knew how to brief and argue a case. The truth is, I have been in one lawsuit or another continuously for the last eighteen years. I have been in a Federal Court with a jury (we won big in that one). I've been sued by a competitor, also in Federal Court, and we won so big that the guy turned over his company and patent to us.

More recently, I've been involved in a famous divorce case (published in CA) where my ex-wife sought spousal support of $15,000 per month *permanantly* and $2.5 million in cash for her share of my company, claiming that she had participated in the invention of the Gary Fong Light-sphere®, a product that sold in the tens of millions of dollars. According to her court filing, she was sitting next to me and watched as I took a table napkin, shaped it like a lantern and placed it over a flash unit as an experiment. That was three years before I invented it! Long story short, the judge awarded her a grand total of $2,450 for my company and zero for spousal support.

So I am really familiar with lawsuits. When I argued the UPS case to the appeals court, the UPS attorney said that when I authorized shipment of the package, I had signed some kind of "UPS Terms and Conditions of Carriage" statement, which limits UPS's liability to $100 or the re-placement cost of the item. The judge asked the UPS attorney if he had any evidence that I had read that clause.

> **UPS ATTORNEY**: *It's on the back of every air bill.*
>
> **JUDGE**: *How do you know Mr. Fong read it?*
>
> **UPS ATTORNEY**: *Because he would have had to sign it to ship it in the first place, and on the signature area, it says that they agree to comply with the*

terms and conditions.

JUDGE: Show me his signature.

UPS ATTORNEY: Well, that's the thing. We don't have it. I'd have to go into our main computer to dig up a scan of his signature.

JUDGE: I'm not continuing this hearing. I'm making my decision today with the evidence in front of me.

UPS ATTORNEY: Sorry, Your Honor, we don't have it.

JUDGE: Mr. Fong, do you have a copy of your signed air bill?

ME: No, Your Honor, but I do have a piece of it attached to a torn part of the cardboard box, which (according to a forensics expert at LAPD) has been run over by at least one car on an asphalt road. A retailer on the route of the UPS driver who found it as he was sweeping his entryway provided it to me.

Kapow!

The judge upheld the original $5K judgment, then added around $3,300 on top of that. The UPS attorney wrote me a check from their insurance company on the spot. We shook hands, then I went straight to the couple to write them a check for the $8,300.

"No, no, no, you keep it! We insist!" they said. "You gave us a new album, and you fought and won both cases! We insist!"

I said, "Okay, I'll keep it." I immediately followed this with, "Here's an $8,300 gift for your wedding, and it is not polite to refuse gifts."

They accepted the money and took a beautiful trip to Italy for their belated honeymoon.

You'll do well to remember this story. From a truly disastrous circumstance, my studio was able to create a magical outcome. The couple received a free wedding album and photography, plus over $8,000 in cash, for an accident I didn't cause. True, I was out of pocket about $10,000, which was rough, but I booked four weddings from this couple's referrals—worth about $80,000 (based on my average sale per wedding at that time). Each of those couples said, "What you did was such a wonderful thing, we wouldn't trust our wedding day to anybody else."

Not only did I restore their faith in me, and maybe in humanity in general, but I also restored their faith in wedding photographers. Conversely, when something goes wrong, and the wedding photographer covers up or disappears, it hurts all wedding photographers.

Jump In! Just Do It!

A few days ago, I saw a video online (do a YouTube search for, "Zach and Jody: Wrap Up) of what appeared to be the definition of a Rockstar couple addressing a small group of admirers for an interview. This highly stylized photo-couple's claim to fame was that by their third year, they were earning a "six figure income" in wedding photography. Okay, I'm not sure this is enough to confer "prophet" status on anyone. But what really made me cringe was a comment Zach made when asked by a nervous follower, "Janelle," how one knows when one is really ready to go full-time as a wedding photographer.

Zach responded, *"DO IT! Now! I think what really holds us back is right here — we lack the confidence and the drive. I love Timothy Farris' book, the 4-Hour Workweek, and in that book he says, what's the worst that can happen if you take a risk? Do you really think you'll be on the streets, homeless, holding a can, trying to get a dollar for food? Do you really think that's going to happen? NO!"*

He then went on to say something that made me want to hurl a beer at his video image (but I don't drink beer, and I don't throw things).

"Janelle" expressed her fear that her house would be foreclosed on, and he puffed out, "It's not! It's not going to happen!"

This is a very irresponsible use of the podium. If that lady loses her house, she can thank those two for misdirecting her.

You <u>can</u> lose your house, and your freedom too! I know someone who got a little behind on filling his wedding album orders. This snowballed into an avalanche of late orders. Due to family circumstances, he had to move to another state, but he kept his phone number, while closing the local studio.

A "consumer action reporter" from a local news station got wind of his move and did a show on the wedding photographer who skipped town and left brides crying. This triggered more people to call in, which made the story even bigger. Eventually, the state Attorney General's office picked up the case. Since the photographer's clients were from Ohio, Florida, Texas, and Colorado, it became a federal matter.

Law enforcement officials flew down to Florida, handcuffed him, and sandwiched him between them on a plane to Ohio. Because his wife told the corrections facility that he was a suicide risk, he was placed under suicide watch (as in 24/7 guard watch, sleeping naked, stripped of all his clothes) until his arraignment. He was convicted of a felony, and was sentenced to jail time with parole. He was ordered by the court to fill his orders to the plaintiffs, and spent the next chapter of his life under house arrest, wearing an ankle monitor.

So in this case, Zach and Jody were right. Technically speaking. The guy didn't end up on the street panhandling for money. He had a roof over his head and three square meals. But he did lose everything he had, including, eventually, his marriage, and of course his freedom and his right to vote for the rest of his life.

But another photographer I know may not be so lucky.

As this book is going into press, he is being sued for $300,000 by a client/attorney. The client posted nearly 1,000 images to Facebook, with friend comments saying, "Beautiful","amazing","good", etc.

I saw the images myself – and they are excellent. They show a high standard of skill, creativity and technique. Regardless, the attorney wrote the wedding photographer threatening, and I quote:

> *...we are demanding $3,800 plus $15,000 to drop this entire matter...otherwise, YOUR ENTIRE LIVELIHOOD IS ON THE LINE. Here's what will happen if you do not pay. Your reputation will be ruined, your livelihood destroyed, your life will be miserable defending a huge lawsuit, and you will be in financial ruin...I will hire a person who specializes in Search Engine Optimization. I will blog about this extensively. Be guaranteed that anyone who searches for your name will find what a disaster our wedding photos were... I WILL SUE YOU UNTIL A JURY VERDICT... you cannot win in a lawsuit...even if the jury agrees with you, (by some miracle) how much do you think you will need to spend on paying a lawyer? I guarantee you, by the time this gets to a jury, it will cost you at least $50,000 in lawyers fees. YOU WILL NOT GET THESE FEES BACK, EVER... so if you don't comply with our demand, it's a NO WIN SITUATION... I wi.. get my judgement for $300,000. I will file a Writ of Garnishment with all your employers and banks, place a lien on your houses, Subpoena you to court for Supplementary proceedings to find out what assets you have, and pursue the matter until all $300,000 is paid in full. If you fail to appear in*

court, I will have the judge issue a bench warrant for your arrest. Then next time you get pulled over, the cop will arrest you... I will sue your wife... (yes, your wife too, since ours is a community property state. I will end up garnishing HER wages from the bank as well..."

So, Zach and Jody? What will be the worst thing that can happen? Are you sure you want to tell that lady in the audience just to jump in? Do you want to be responsible if this type of thing happens to her? If that does happen, will an apology be enough to heal the hurt?

The decision to go into wedding photography full-time is not one to take lightly. You accept a great responsibility and you expose yourself to the risk that you could lose everything. Just do a Google search for "wedding photographer bankrupt," or "wedding photographer jailed." Then ask yourself if you still trust the YouTube speaker who so glibly encourages would-be pros to "jump on it."

Even if you're seasoned enough to take this kind of facile advice with a grain of salt, there is a new busload of fresh young photographers arriving at your local depot every day that knows nothing about who is credible, who is not, and who is a downright fraud.

What really troubles me is that the people who get burned are reluctant to criticize anyone publicly out of fear of ostracism or backlash from the industry.

And so I have tried to serve as a sounding board for some of these complaints. As a result, I've become a sort of unofficial "Consumer Action Reporter" of the photography social media world. It's a burden to carry, but I'll continue

to do it as long as there are confused photographers out there who need someplace to turn.

In the next (short) chapter I'm going to share my final thoughts about where our industry is headed and how you can fit in.

What If Yoga Remained Ungoverned?

We're not alone in the business of amateurs masquerading as professionals. For example, things got a little bit crazy for a while there with yoga instructors. Yoga "experts" were popping up everywhere, and a decent percentage of them were highly unqualified. This was not a desirable situation; an untrained yoga instructor can cause serious injury to people.

True yoga instructors (Yogis) decided to take action.

In 1999, a governing body called The Yoga Alliance was formed, with a certification program that required instructors to go through 200 hours of training before they were certified to teach. Yoga studios wisely adopted this standard everywhere, so that only certified instructors were allowed to teach classes.

What would have happened to yoga had the Yoga Alliance not been formed?

- *Would unqualified instructors continue to teach improper techniques?*
- *Would people get injured?*
- *Would yoga studios keep popping up like Subway franchises?*
- *Would poorly trained instructors give workshops based on erroneous ideas about yoga?*
- *Would their students turn around and give their own workshops within months?*
- *Would communities of "newbie" yoga instructor's form?*
- *Would they call true yogis "grumpies"?*

- *Would Rockstar yoga instructors go on tour, inspiring beginner students to "let go of your fears and insecurities, and just 'do it'! Be a yoga instructor!"?*
- *What would happen to the reputation of the true yogi?*
- *...of yoga in general?*
- *Would yoga be as popular as it is today, or would it have run aground because of public distrust and distaste?*

Without a set of agreed-upon credentials, anybody with a video camera and a svelte physique could call themselves a yoga instructor. Think how hot you sound when you use that title. Just saying the words gives you a veneer of being fit, flexible, gentle of spirit, and dedicated to self-improvement.

I've taken at least 200 hours of private, one-on-one yoga instruction from qualified teachers. I practice yoga 1-2 times a week. And the only poses I can remember by name are Downward Dog, Cobra, Warrior 1 and 2, and Plank. There's no way I have any measure of qualification to be a Yoga instructor.

But let's say I wanted to become one because it sounded Rockstar glamorous. I might daydream about how cool it would be to teach yoga, but I'd be on the fence because I'd feel — appropriately so — that I'm not skilled enough.

Then one day, let's say I go to a seminar that completely inspires me. I decide I can do this. I just need to let go of my fears and insecurities. I just need to go for it. So I sign up with the company sponsoring the seminar, whose product line is tailored for the beginning instructor. I'm

invited into a community of like-minded people and love being a part of the group. Together with them, I feel almost silly limiting myself with the idea that I'm not "good enough." So I take the leap and Gary Fong, Yoga Instructor, is born. I start a fan page on Facebook, and already I'm getting hundreds of "likes." Why, people from Terre Haute, Las Vegas, New York, and Beverly Hills have "liked" me just in the past week alone!

You get the idea.

I can totally see how his could happen. And I can see the appeal. Single? Think how many hits you'll get on match.com when you put "Yoga Instructor" on your profile. Is money a bit tight? You've seen other yoga instructors on Facebook rake in thousands of dollars for a two-day yoga retreat.

True yogis, on the other hand, might not be so Internet-savvy. They might not tweet all the time, or have fan pages. On the rare occasions that they would post on forums, perhaps pointing out how the new crowd was misleading the public, they might be called "grumpies" by the newbies.

But back to reality. Yoga took care of business. It cleaned its own house. It established training criteria and required that its instructors be certified.

Photography is not like that. There's no certification.

Should there be? Probably. But I don't know who would oversee it. The professional photography organizations haven't taken any steps, outside of PPA's "Certified Professional Photographer" program, which gets absolute-

ly no mindshare in today's Internet world. In fact, PPA has done such a poor job of achieving visibility that to consider its certification program remotely equivalent to that of the Yoga Alliance is not realistic.

So, unless and until a standard certification program gains footing, there needs to be a better way for photographers to show their rank — Private, Sergeant, Lieutenant. or General. Their needs to be a sharper way to showcase the professional divide, the borderline that separates the experienced pro from the rank amateur.

Build Awareness on a Client-by-Client Basis

How do we go about widening this professional divide? Well, some folks are already doing it. There are big success stories among today's photographers. There are excellent shooters who started only a few years ago, but who have built a solid clientele and reputation.

And those last two words are the key that has made them what they are.

Clientele. Reputation.

Those are the words to pay attention to. Not "likes" or "retweets." Having a great Clientele built on your Reputation (for excellence) is the way to command the higher fees. You can't achieve this by buying a DVD on "How to Book High-End Brides." And this is why so many photographers who take the leap to pro never make it to wedding number two. Unprepared for the pressure of the event and insufficiently trained, they narf up their first wedding and have such a painful experience they never want to do it again. They'd rather give themselves a root canal with a rusty butter knife.

It has been suggested that I, have something against "newbies." Nothing could be further from the truth. I spend a great deal of my time, on a daily basis, helping and encouraging new people. Why? Because photography is awesome. I do not want newbies to fail, and I feel that jumping in before they are prepared is one of the surest routes to failure. That's why I advise so strongly against it.

It makes so much more sense to wait until you are fully trained, prepared and confident, before you shoot that first

wedding. Then you've earned your stripes as a Sergeant or Lieutenant, you've served your apprenticeship, and you are confident in the field. You know you can deliver under pressure. You know you can tap your creativity and get amazing shots even with the most uninspiring backgrounds. You know how to talk to your subjects, and you know how to pose people properly. (That's a whole book in itself—for now I'll give you one quick tip: if you shoot people with a wide angle lens, never go below their waist!)

If you wait until you are confident and prepared, your first wedding is likely to be a huge, encouraging success, rather than an unmitigated disaster for both you and your clients. From this happy event, you'll gain referrals because clients know your reputation with their friends and family and they've seen your stellar work.

Reputation and Clientele—not clever Tweets—are the foundations that set the stage for a lasting, successful, and thriving business.

Advice For The Novice

It's not that complicated, but it's not exactly a Rockstar formula:

1) *Start with reasonable prices and work hard toward perfection.*

2) *Do not quit your day job. Don't just "jump in and do it."*

3) *Send my Instructor Questionnaire to any instructor who pitches you to attend their workshop or to enroll in their consulting services. How they handle your request will reveal a lot about their integrity.*

4) *Make absolutely sure Client One is tremendously, ridiculously happy.*

5) *... happy enough to give two super enthusiastic referrals.*

6) *Raise prices incrementally after you reach your yearly goal (for example, if you aim for 14 weddings, then as soon as you book #14, raise prices by 10%. If you don't reach 14, keep your prices steady.)*

7) *Before you get the itch to offer a seminar or workshop, fill out the Instructor Application yourself. This will give you an objective look at reality and your qualifications.*

Repeat steps 1-7 and constantly work on improving your photography skills, your merchandising, and, above all, your customer satisfaction. Strive for perfection in all areas of your business. Don't worry about collecting "likes" on Facebook, worry instead about being genuinely liked — because you did everything in your power to make each client's customer experience a total joy.

Advice For The Seasoned Pro Losing Business

1) *Work on boosting the visibility of your expertise. Do this by educating the client as to what kinds of questions they should be asking of photographers. Fill out the "Disclosure Declaration" form shown earlier in this book, and give your potential clients several blank ones for them to use. Suggest that they ask any photographer they interview to fill out this "job application." This will clearly illustrate the difference between your experience and that of the others, and will be a great booking tool, I'm sure of it.*

2) *Make sure all of your clients are super happy and have no hidden issues, so that you can start the referral pyramid "pre-filtered for price."*

3) *Consider not lowering your prices in response to the tide of Craigslist discounters. Chopping prices will make your attitude bitterer. That, combined with having to do more volume to earn the same income, will lead to more mistakes, understaffing, and poor customer service. Which, in turn, will get around on the viral Internet, so that fewer people will want to entrust their wedding day to you. This is the downward spiral. I've seen it a million times.*

4) *Cut your overhead as much as you can. I know a couple of the best celebrity photographers (they've shot Jennifer and Brad, Katie and Tom, and others) who have closed their studios and are now content working out of their homes.*

5) *Don't express your anger when you lose clients to inexperienced photographers. The client who does not book you may later refer you virally if she ends up regretting going with the cheap photographer. This is a key referral source; the client who regrets they didn't pay a bit more and hire you. However, if you act like a jerk with the client, they're not going to refer you, no matter how much they realize that you were perhaps the wiser choice.*

6) *Maintain your patience and your dignity. Be grateful that the clients you do have appreciate where you fall along the professional divide.*

Epilog: Why I'm So Passionate About This

My wife and I are new parents to a beautiful set of twins. Being a parent has brought me joy that I can only describe as a feather inside my lungs, constantly tickling my every cell. I feel as if I'm living in a daydream where I often ask my wife, "Is this really happening? Are these really our kids?"

Then the bubble pops when I hear of someone being hustled by some Internet impostor or seminar sleazebag. I go berserk for a while, spending hours of my day speaking to the victim(s) and trying to find a way to get them whole again. For some reason, this kind of thing really gets under my skin.

When writing a book, there is a procedure I like to call "assembly." It's when all of the unedited pages fall into place. I've written one book that's been published, and two books that I haven't tried to publish, because even though the individual pages were good reading, they weren't cohesive enough, during assembly, to polish into a jewel.

Every author strives for the joy of having a book write itself. It's like hitting the perfect drive in golf, or acing someone in tennis. As regular humans, we usually obtain irregular results, but we long for that moment of perfection we touched once, a moment we wish we could repeat again and again.

This book was the epitome of the self-writing book. Perhaps it's because ever since I was ten years old, I've kept a journal, where I've recorded my observations on life. My frustration and disappointment at seeing my esteemed colleagues go the way of the fast buck led me to write

many of these stories, simply as a therapeutic tool. Many days, I would just sit here and watch my fingers type all by themselves, filling the pages with very little effort. It felt good to write this book, as I hope it will feel good for you to read it.

So why, you may ask, am I unable to ignore all of this chatter happening in a profession that I left nearly a decade ago? Let me share with you a story.

As some of you may know, I grew up in a struggling immigrant family that constantly teetered on the brink of poverty. We lived paycheck-to-paycheck, and less. My dad was often out of work as an electrical engineer, and all we thought about was how to get through the next month with a roof over our heads. This terror left a huge mark on my psyche, giving me what most people would call "issues."

One day, my folks and I were watching TV and we saw a commercial for a company called Idex Corporation. It appeared to be a legitimate company staffed by experts in bringing million-dollar ideas to market. The ad challenged the viewer with, "Do you have an invention that could make you millions? Then call us today!"

Well, Mom had an idea that would be considered by most to be pretty darn silly. She attached snap buttons to our blankets and sheets, so that the sheets wouldn't get all bunched up separately from our comforters as a result of tossing and turning at night (caused, n0 doubt, by all that worry about our finances).

We called the number "today!" as the commercial suggested. Before I knew it, I was sitting with my parents in a

meeting at the Idex Corporation. I was only seven years old, but I remember the slick guy in the plush office with the fancy suit, brazenly convincing my mom that her idea of sticking little metal snaps on sheets was brilliant. He said it was a "million-dollar idea."

We were so excited. My dad took $2,500—most of his life savings—and sent it to the man at Idex. This was in 1967, when a brand new car cost $2,500. This is probably equal to $25,000 in today's dollars—from a family that worried about where it was going to live next month.

My dad had always been a squirreler, and he put away money that he swore that he would never touch unless there was a dire emergency. That $2,500 was never to be used for everyday life. Never. But this slick Rockstar salesman got him to part with it.

What did we get for our family's life savings? A three-ring binder with an artist's illustration of a bed sheet buttoned to a comforter on the cover, along with a gold foil, title, "The Integrated Bed Sheet, by Yong W. Fong, Inventor." Inside the binder were Xeroxed pages detailing the size of the bedding industry, reports on how many bed sheets were sold per year, and diagrams with the exact specifications of sheets in Twin, Double, and Queen sizes. And that was it. As a family, we knew we had been had.

We had been daydreaming about going on a family vacation and living in a mansion, while Dad quit his job and Mom sat around counting the royalties. That salesman had convinced us we were destined for a Rockstar lifestyle.

Dad put the binder away; he got sick from looking at it.

I, on the other hand, opened it often, and absorbed every detail carefully. I knew it for what it was, a scam. But while my dad just wanted to forget the whole thing, I wanted to imprint the experience on every cell of my body so that I would never let this happen to me, ever.

Today's Rockstar-lifestyle promoters remind me exactly of the Idex Corporation. What really disturbs me is that some of them were my friends!

I never really wanted to be rich and famous, I just wanted to get as far away from poverty as I possibly could. So I worked harder than anybody I knew for a couple of decades, until I finally became comfortable living on the other side of the tracks. Fame within my industry only came because I created products that I was super excited about, I couldn't wait to show them to anybody who cared to listen. My audience became a worldwide one only because I couldn't stop jumping up and down in excitement over my new invention(s). Being Rockstar famous was not a goal.

My editor for The Accidental Millionaire described my life as a process of becoming the polar opposite of my father. My father is fearful, hesitant, intolerant of any risk whatsoever, while I'm trusting (to a fault), open-minded to all opportunity, and a risk-taker. My editor summed it up as, "Your father was scared to death of losing what he had, while you were scared to death of missing an opportunity."

In writing this book I suddenly saw a clear picture of why my father became so untrusting and fearful. It was Idex Corporation. That Rockstar salesman acted like he cared about us and that we would all work together to see Mom's idea to market. As soon as he got our check, though, he stopped returning our calls.

Dad never really trusted anybody after that. The whole experience really, really hurt our family. To the marrow of our bones. It stabbed us in the tender areas of our hearts. Not only did this Rockstar take away our money, he took away our dignity, as we were so embarrassed by being hoodwinked like this.

Have you heard of Creflo Dollar? He has a Sunday morning broadcast, and I tuned in one day while bored in a Seattle hotel room. There was Creflo on the podium, preaching the prosperity gospel. And he said the following to a stadium-sized audience, no joke: "God told me that by September, there's not one, not two, but three people in this audience who are not only going to be billionaires, but trillionaires." To which he added, "God told me this directly. And God ain't no liar!"

The camera then panned to this young family, a plain-looking woman with waist-length wavy hair and her husband, a bespectacled, heavy-set guy. They were crying with joy, hoisting their young girl over their heads yelling, "Hallelujah!"

Creflo Dollar then left the stadium and flew away in his private jet.

Hmm, if Creflo was right, then three people in that same stadium would, by September, have twenty times the wealth of Bill Gates. Wow. The Gross National Product of the entire United States is about 14 trillion dollars. Those three people in that stadium, together, were going to sock away an amount equal to a quarter of the entire United States economy within a few months. Nice work if you can get it.

The sad thing is, though, that poor, naïve couple bought it. With tears to boot. And they probably dug into their own wallets to support the mission of the aptly named Pastor Dollar.

September came and went, and, of course there was no new trillionaire on the Forbes 500 list, much less three. But Creflo is still out there filling stadiums. That's the nice thing about being a profit, er, prophet: you don't even need to be right.

In my world, though, phonies can't just suck people dry with no consequences. So I will continue looking out for you, the trusting ones. I will always try to warn you about the dishonest predators out there, even if they were once close friends of mine. I will continue to strike back when I hear of the damage that is caused by people who chase the fast buck without regard for the human trust they violate.

And you know where to find me. I'll be on the social network, right along with all of the Rockstars.

Watching like a hawk.[1]

If you enjoyed this book, please Tweet to your followers! Thank you!

Book purchases: buygarysnewbook.com
Facebook: www.facebook.com/gary.fong
youtube: GFIGARYFONG
twitter: garyfong_real

[1] www.soyouwanttobearockstarphotographer.wordpress.com

about my mentor:

Rocky Gunn is the man who got me here.

His advice, "nobody needs a salesman knocking on their door, but everyone could use a good friend" has helped me find success by building businesses one relationship at a time.

When I asked him if I should burden my parents with my room and board expenses after I graduated college (for a year so I could become a wedding photographer), he said, "If anyone offers you help, don't turn it down, instead take that help and go as far as you can. That's how you'll show how thankful you are." So I'm thrilled that my parents were able to see what I became as a wedding photographer.

Rocky really wanted me to pull others up to the "top of the hill" once I got there.

He never made a lot of money at what he did. He was just starting to sell products to photographers. One day he shared his dreams with me. "Maybe by selling photographic products, I'll be able to buy a big house on a hill." It was as if he was looking in a crystal ball to my future.

It's a shame that few remember Rocky. If you Google him, you won't find much, other than he had a country and western song that hit the charts once, and he was on the "Kung Fu" television series. But he was the superstar at the very first WPPI, thrilling a huge crowd with his posing techniques.

That got him a six-page spread in LIFE magazine. (July 1982) That's what prompted me to contact him again. I'd first met him when I was 10, when he was a lounge guitarist at the Korean Restaurant where my mom was a server.

I told him that I was now a guitarist, so on the day we met, he asked if I had my guitar handy. I had my Ovation acoustic in the trunk of my car, so I pulled it out. We walked to the Redondo Beach Pier, and sang a duet of "Leaving On A Jet Plane". A lady dropped a $1 bill into his camera bag, and he said, let's use this and buy donuts!

He died at age 42 of a heart attack. His eating habits made him a time bomb ready to explode. I watched him as he ate an entire pack of bacon (raw) and a half gallon of ice cream as we were talking.

He wasn't overweight, in fact, he was a Kung Fu expert. One day I asked him how he got a black eye. He said "Chuck Norris did that, but you should see what I did to Chuck!"

His presence was larger than life. He shot Hasselblad cameras, but *without a meter*. He'd just stand in a room and say, this room is 1/60th of a second at f2.8. And he'd always nail it. He taught me how to do that, and he taught me how to memorize wedding party names in an instant.

I wish you all could have met him. I swear he would have changed your life. I'm sad that you'll never get to know him because he was a gift to the world. He inspired and challenged me. He didn't fill me with false dreams, in fact, he warned me, very seriously: "You'll never get rich as a wedding photographer. You'll never be a millionaire doing this, but you'll always eat well."

Well, he wasn't always right about everything!

I took his help and went as far as I could, and while I wasn't able to show him my thankfulness by showing him

how far I went with his help, I will always help others climb the hill.